MIRAGE

MIRAGE

BY BORIS VALLEJO
TEXT BY DORIS VALLEJO

GUILD PUBLISHING
LONDON

ACKNOWLEDGMENT

I wish to express my gratitude to Danielle Anjou. To attempt to do justice to her contribution to *Mirage* in this limited space would be frustrating and finally impossible.

Over a period of two and a half years, Danielle not only brought to the long posing sessions her experience and talent as both model and photographer, but also contributed many imaginative ideas and offered helpful suggestions for the paintings that follow.

FOREWORD

"Where do you get your ideas from?" people frequently ask Boris, as if a secret formula existed that, once grasped, would open the floodgates of creative imagination. Although inspiration sometimes comes in flashes at that nebulous point between sleeping and waking, most of his ideas are not accidents of dreaming. Imagination, he believes, is a quality to be developed just like technical skill. The more it is used, the more readily it responds to the subtlest stimulus: clouds, shadows, a curtain blowing at an open window, a figure half glimpsed out of the corner of one's eye that might spark the thought, *if I put wings on that...*

Boris' skill and imagination have been developing since he was old enough to hold a pencil. When he had no paper (sometimes a scarcity in his childhood) he drew on the walls. These murals, if not communally appreciated, became excellent gauges of his progress; the relative insecurity of his early drawings was exhibited near the floor, while increasing skill and confidence became evident as the drawings rose toward the ceiling. While many of the first sketches were carefully copied from the comic strip *Popeye;* the later ones, the beginning of his work with oils, were more often inspired by the classicists (a daVinci influenced "Last Supper" mural eventually, if somewhat ironically, graced one diningroom wall).

The idea for this book grew out of a combination of love for the human body and frustration with a censorship that divides it into parts; designating some as "decent," others as "indecent." As a commercial illustrator, largely bound by manuscript specifications and the client's prejudices or concerns about marketing eccentricities, Boris can choose to shrug his shoulders and paint the requisite pasties and G-strings to insure a heroine's coy modesty, or to laugh (as when the barebreasted amazon of one of his paintings was returned wearing cut out photos of hubcaps crazily doubling as breastplates). The only other options were to refuse restrictive commissions outright or to become his own client, a choice which, in time, gained increasing appeal.

Originally this was planned as a book of nude studies, black-and-white sketches, to be published independently and sold through the mail. Upon more critical thought, however, a simple collection of black-and-white studies appeared to lack sufficient drama as well as to represent a lesser challenge. Also, the inherent problems of a small publishing venture attained, in time, a disconcerting reality. Thus the plan changed: the book would be more ambitious, the publication would be undertaken by Ballantine.

Nudity and eroticism have become intertwined in popular thinking. The *erotic* (defined by Webster's as "pertaining to or prompted by sexual feelings or desires; treating of sexual love; amatory...") is a motif that intricately threads all human behavior. Hence, combined with the fantastical or mythical elements so representative of Boris' work, it provides the distinctive unifying theme for this book.

Yet, as the ideas for the paintings themselves developed, it became clear that a more careful exploration into the ramifications of "erotic" was important; the portrayed coupling of creatures (whether human or hybrid), the straining toward orgasm—while easily recognizable as erotica—was too superficial. Boris sought to reveal something far subtler; something that did not explain the erotic experience but was itself the experience, inseparable from the larger human experience. As such it must touch on the wide spectrum of human sensibilities—from fear, pain, and frustration to hope, fulfillment, and exultation.

Among the discoveries was this: the way light caresses skin almost causing it to glow in places; the curve of a head every bit as much as the curve of a breast; the unexpected; the startling red of blood— all may become aspects of the erotic experience.

The paintings invariably give rise to questions: "What do they mean?" "What is the story you're telling?" (One cautiously disapproving critic expressed the opinion that it would be refreshing to see landscapes instead of so many naked bodies.) Sometimes the answers are self-evident. Sometimes there are several answers or none at all. But no painting makes a finite statement.

The purpose of blending creatures with humans was to create a fanciful integration of possible and impossible, human with inhuman. But attempts to nail down *meaning* too exactly tends to limit rather than define "the story." The substance of these paintings (as that of the poetry they inspired) should touch us at many levels and, like consciousness itself, disclose a continuing variety of possibilities and discoveries. Therefore, the ultimate "story" of each painting is something that every viewer must, ideally, find for himself.

Doris Vallejo
New York, 1981

MIRAGE

*This is the studio: a curtainless bay window hung with plants,
through which the southern light falls in speckled patterns
(Boris doesn't depend on natural light for painting. He prefers
a combination of warm and cool fluorescent lights which give
him a facsimile of natural light that is unmoving, unchang-
ing). A massive darkly stained oak desk supporting an eclectic
clutter—books, letters, magic markers, prisma color pencils,
two adding machines, an unused Kodak color film processing
kit (it has been there for months awaiting the free moments in
which Boris plans to do some work in the small darkroom on
the third floor). Two scarred drawing boards the reminders of
our days of doing advertising art—equally cluttered ("A neat
desk is the sign of a sick mind," reads the plaque on the desk of
an attorney we know. It would be appropriate here). A huge
bookcase holding an extensive collection of reference books—
The Illustrated Encyclopedia of the Animal Kingdom, Jacques
Cousteau's THE OCEAN WORLDS, books on mountains, des-
erts, and trees, books on the classic painters as well as collec-
tions of contemporary artists, books of photographs as well as
books on photography.*

*There is also a cork wall on which posters, bills and odd
reminders are pinned alongside three mounted ceramic mon-
ster heads that appear to be on the lookout for a nightmare in
which to happen. (Boris countered my aversion to such gro-
tesques by enthusiastically reasoning that these fang-toothed
zombie-eyed horrors would inspire him in the dreaming up of
his own uncanny creatures.)*

*There is a sofa flanked by tall narrow bookcases that house
colored inks, photos from various shootings, linseed oil, turpen-
tine, and a taped music library. Boris always listens to music
when he paints; classical music mainly but, on occasion, also
the affecting melancholy ragtime of Scott Joplin. In fact the tape
recorder is connected to the light switch in the studio and the
music often goes on automatically when the light is turned on.*

*There is a TV, a music stand (sometimes he plays his violin
as a break from having painted too many hours at a stretch),
several chairs, a tabouret for brushes and paint and—the real
focal point of the room—his easel on which, at the moment,
stands the final painting for Mirage: Day Dream. He works
on it as we talk. Its background—the pale mountain in the
distance, the vivid sun-touched cliffs rising on either side, the
waterfall rushing down between them—is finished. The lady
and the fawn, sketched in the foreground, are still in the pre-
liminary stages and appear translucent as ghosts.*

*Such is the magic of Boris' work that, standing in front of
this painting and studying it I can almost hear that dazzling
waterfall roar down the cliffs; I can almost see the iridescent
foam rise, dissolve like a cloud, rise again, dissolve and rise
continually...*

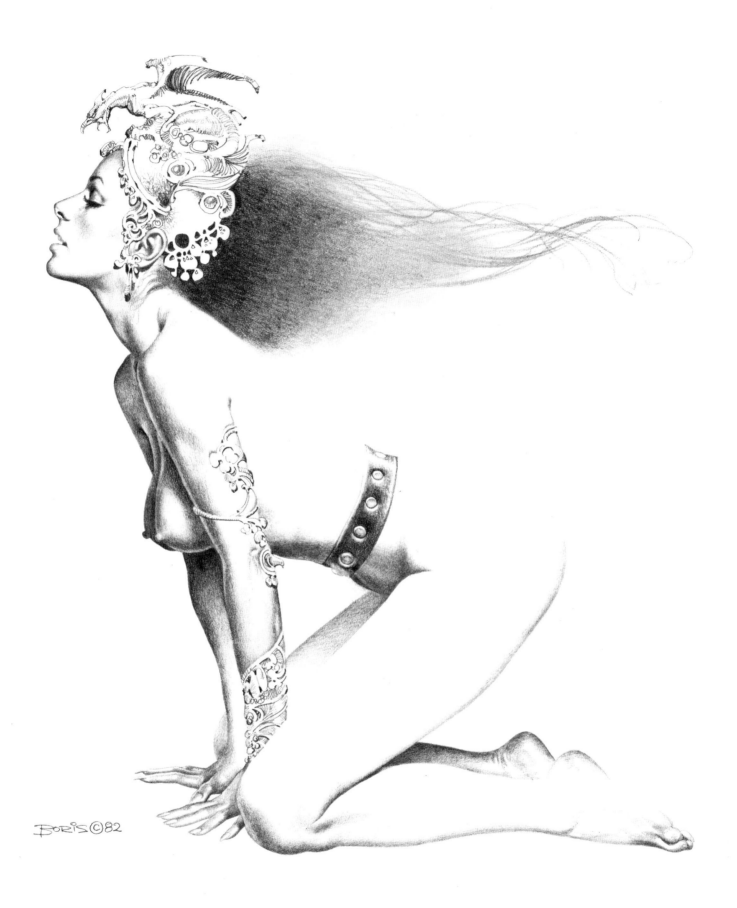

Boris ©82

"I started taking formal art lessons when I was fourteen years old at which time it certainly didn't dawn on me that I could ever earn a living at it. This revelation only occurred when I was actually offered a job in the art field—an inauspicious beginning, I might add—doing diagrams for instruction sheets on assembling metallic structures. I lasted about a month and a half, maybe two months. It was a part-time job in any case and I hated almost every minute of it. Once I started at the university there was, happily enough, no time for it.

"My first full-time job after I had decided not to pursue a medical career didn't last more than two months either. Not altogether surprising since I was hired on the basis of some samples a friend of mine was generous enough to lend me and I was optimistic enough to show as my own. At the time I thought: what's the difference? But once I began working the 'difference,' namely, that I lacked the experience, the skill, the knowledge, the imagination to produce the kind of finished layouts they expected, became all too obvious. So, I did odds and ends of lettering until the art director got fed up and told me to go home and practice for a while and then come back when I was ready.

"That is what I did too. However, they didn't hire me a second time. In fact, when I showed up with my new samples I was told the art director was too busy to see me and that, in addition, he had a headache.

"Consequently I went on to bigger and better things which, in plain language, amounted to occasional freelance work. Mostly I collaborated with a former classmate of mine who was an exceptionally talented artist. He coached me, in a manner of speaking. We would discuss various aspects of our jobs; various approaches. He introduced me to the *GEBRAUCHSGRAPHIC* (a Swiss magazine of graphic art) which we would go over very analytically.

"We entered the local art contests, poster contests, and so on. All of which was fine when he won. When I won he invariably got pissed off figuring that he had taught me all I knew and should therefore certainly win over me.

"I gained far more from this friendship, I must say, than I did from the classes at art school. For one thing, in school I was arrogant and preferred to show off rather than to listen. For another, I don't believe I had really qualified instruction. If you study with a good teacher for even six months you can gain inestimable ground. You can learn things that otherwise take you years to puzzle out. If I'd had someone like, for instance, Jack Potter when I was a kid I think that I'd have gotten ahead much faster.

"The one definite advantage I did have at school was the access to life models and the opportunity to draw from them for several hours every day. At that time I would never have approached someone to pose for me. And, even if I had, there would have been no place to work. My mother would have been scandalized if I'd brought a girl home to pose naked."

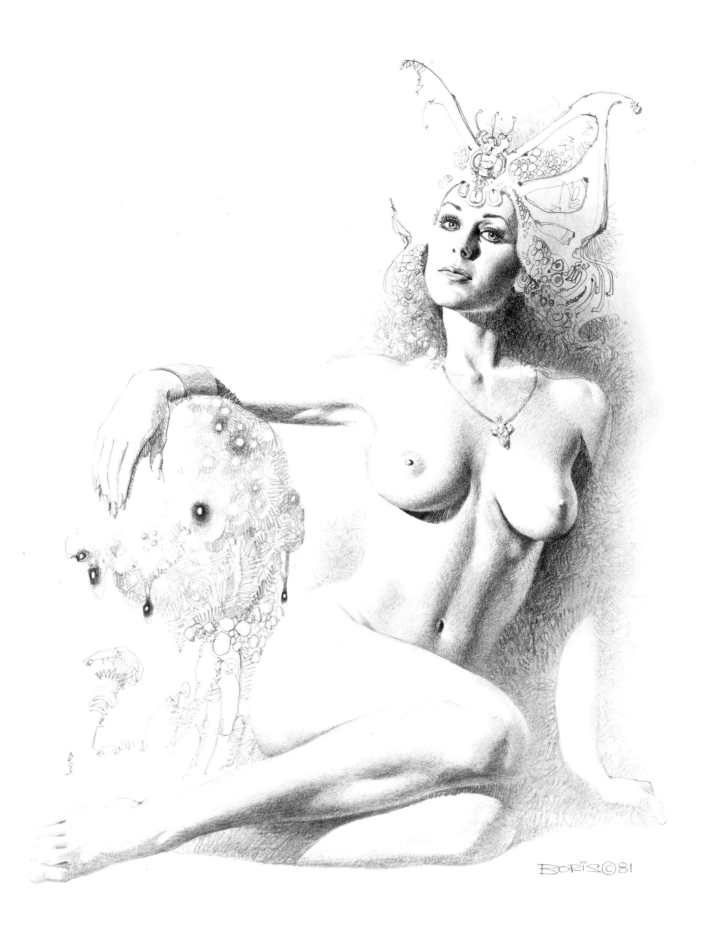

BORIS ©81

"Though it stands to reason that in order to be able to draw or to paint something you have to be able to see it first, this is a less obvious statement than it seems. When I first took my samples to publishing houses I thought they were as good as anyone's. I couldn't understand why no one would give me work. Now it's perfectly obvious to me what was lacking. This is actually one of the major problems that beginners face: not to be able to be objective about their work; not to be able to see. How do you learn that? It takes time. Nobody can teach you that.

"I remember once saying to an art director, 'Okay, I can accept that you're not going to buy my work but I want you to tell me what is wrong with it.' His answer, not very enlightening at the time, was, 'If you can't see it, I can't tell you.' I was rather self-righteously annoyed at him since I wouldn't have asked to have anything pointed out if I could have seen it on my own. It was only when I actually began to see my shortcomings that I realized how true his comment was. You either see or you don't. If you don't then you are not ready to work professionally.

"How should one's weaknesses be pinpointed, after all? By being told: this color doesn't work here; you don't have enough contrast; poor composition; this anatomy is off; etc., etc.? That would be like trying to perfect the English of someone who has been in the country six months—let's say—and is at the point of understanding pretty much what's being said but insecure at expressing himself. Are you going to stop him at every other word to tell him: your grammar is bad; your pronunciation is worse; this word doesn't mean what you think it does; that word doesn't exist? You'd probably stop him from speaking altogether, whereas, given time, he would come to see many of his errors on his own.

"The best way, I find, to learn to see is by being very consciously, very deliberately observant: developing an awareness of positive as well as negative areas, seeking —in any given scene—where the strongest area of light hits, where the shadows fall and how. With me this kind of seeking has always been instinctive, though I have sharpened it over the years.

"A lot of time during my first year in art school was spent copying statues. They had many very excellent reproductions of Michelangelo's sculptures. I had a tendency to make my drawings look like live people and the teacher had to remind me constantly that this was not flesh I was drawing but marble and therefore had to be treated more delicately and with less contrast. Thus I became aware that different textures, different surfaces reflect the light differently. Velvet, for instance, reflects very little light. The contrasts are very soft. Something metallic, on the other hand, will reflect it strongly and with distinct edges.

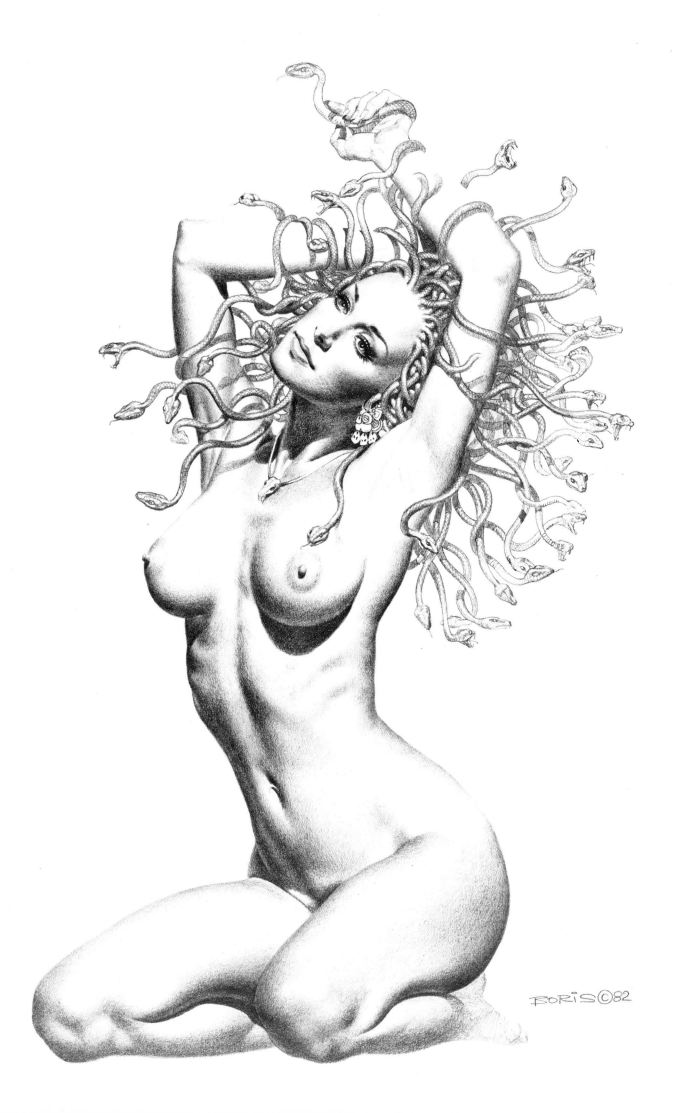

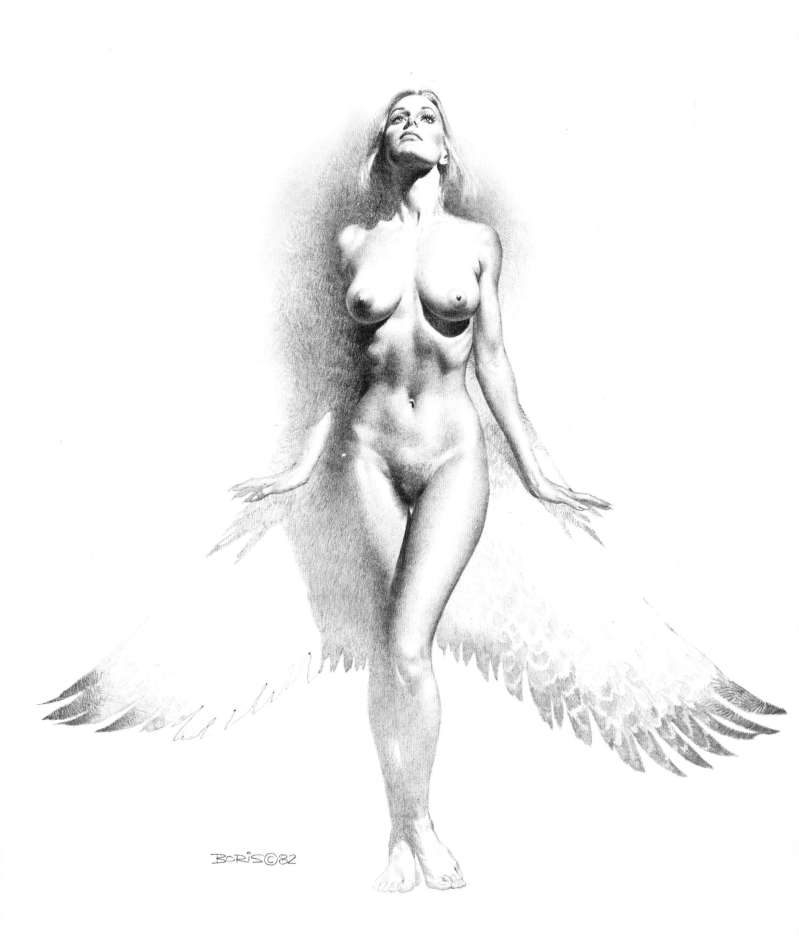

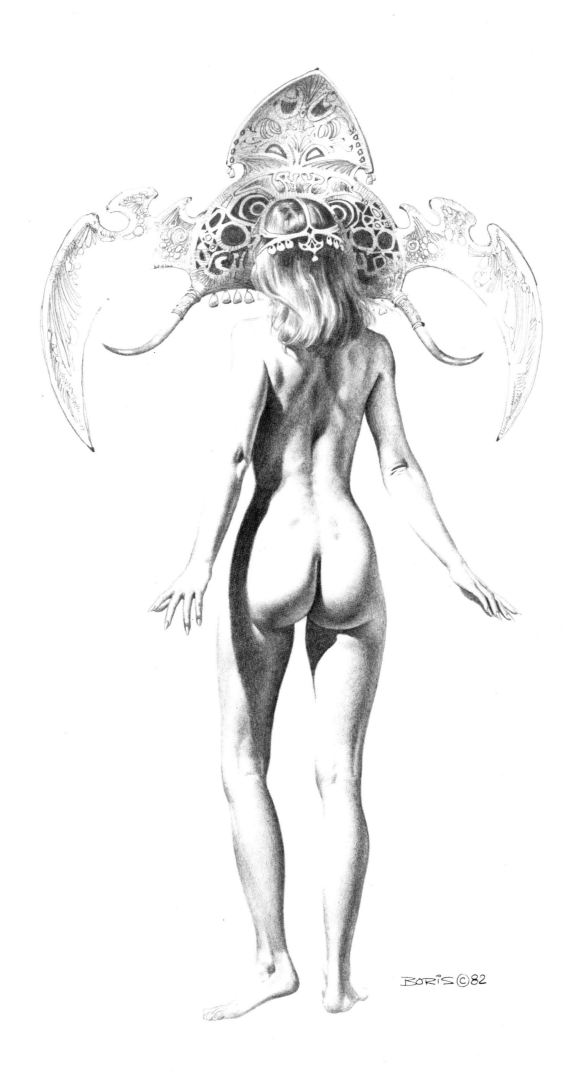

"I marveled, in studying the paintings of Rembrandt, at his use of light, at his colors; those golden colors he got on the canvas that actually seemed to glow. For a long time I wondered how he did that, how he managed to get such an immensely dramatic effect. I tried it myself and it didn't come out the same way. So, I went back to study the paintings some more. And, I experimented some more; tried some orange here, some red there, emphasized this, minimized that. In the process I realized that yellow appears brighter than white on canvas. You would think that white has to be the brightest of all colors. What could be brighter than white? But yellow creates a greater *illusion* of brightness. On the other hand, you'd assume that black is the darkest color, which it is. But it doesn't produce the same illusion of depth as it would if, for instance, you added red to it. Such a combination creates much more contrast with the light areas than black alone.

"You have to remember that the visual effects you perceive are just a combination of colors and of light and dark. If light were diffused equally everywhere things would look flat, two dimensional. In painting, a sense of depth is created simply by propitious use of lights and darks and half tones.

"All this is exactly the kind of process of discovery that might be shortened by a good teacher. I will say though, in defense of teachers, that there are far too many mediocre or outright poor students and, as a good teacher can make a good student, the converse is also true; a poor student can make a poor teacher. Certainly enough people have come here asking for pointers and constructive criticism on their work who haven't understood at all what I've said to them. Who, furthermore, didn't really want to hear it. They didn't want to hear about the necessity of learning to draw before starting to paint. They didn't want to hear that they weren't ready. They wanted to do book covers. They wanted to do movie posters.

"I've noticed some people who come to watch me paint sit for hours with their eyes almost constantly glued to the palette. I suppose they're trying to memorize what colors I put where, which is quite useless. The colors I use in one painting are not necessarily those I will use in the next. These people would gain far more by looking at the canvas, by analyzing what is happening there. I am repeatedly being asked what colors I use for skin tones, and that changes all the time. There just is no single answer."

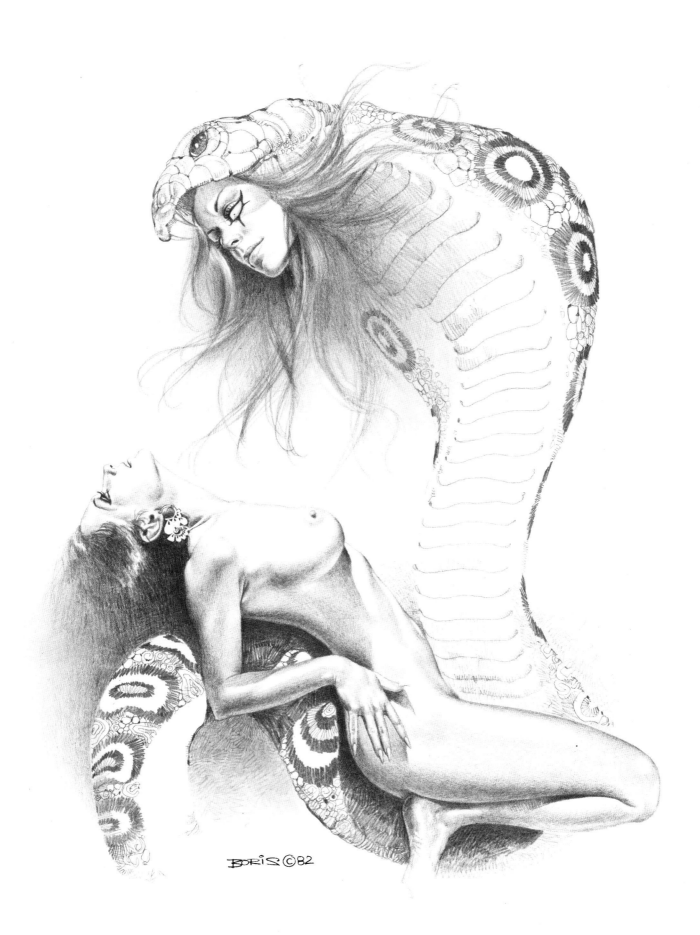

BORIS ©82

"Paradoxical as it sounds, I have often seen artists afraid of using color; strong color, or different colors from the ones traditionally used to create particular effects. I have been asked on one or another occasion why I used a warm color in a background as the tradition is to use cold colors there since they make things appear to recede. Or else, I have been asked why I used pure white in this or that instance, which is also supposed to be a no-no.

"My answer was that once a solid groundwork has been laid, once you have served your apprenticeship, so to speak, you should have sufficient understanding of what you are doing to break the rules. Who is to tell me that I can't use blue in a skin tone for example, or green to create the deepest value somewhere? In the same vein, though I will tell whoever is interested how I achieved a particular effect, I don't presume to make rules for others.

"Needless to say you take the risk of being wrong and of effectively lousing up a painting when you break established rules. On the other hand, you can learn a great deal from your mistakes, perhaps more than from your successes. Furthermore, if you avoid risks, if you stick to the beaten path, you never emerge from the crowd.

"The trick is to view successes and failures in a larger perspective. Each can be a stepping stone to increased understanding and ability, and neither, in itself, determines whether you will rise or sink. I am fortunate in having a fairly circumspect outlook by nature.

"I remember when my brother and I were in high school how anxious he would be at exam time. It was so excruciatingly important to him to get first place that if he didn't, if he got only second—which happened maybe only a couple of times in his life—he would be sick, physically sick to the point of nausea. He wouldn't talk to anyone for days. I wasn't a bad student either. I would get second place, third place. But once I actually placed twenty-seventh in a class of thirty kids. It struck me as quite a joke: 'Guess what, I placed twenty-seventh, ha ha.' Of course my parents didn't exactly take that view. Especially not my father. But I knew it was no measure of my ultimate worth. I just hadn't made the necessary effort to place higher. That was all.

"So-called *failures* don't burden me, don't lessen my enthusiasm or determination. This is simply the way I am. I can't even take much credit for it. Though this state of mind, I believe, can be developed through a very deliberate steadying of one's sights on the long range goal and the nurturing of a self-awareness that will immediately sound the alarm when you start to make self-pitying excuses."

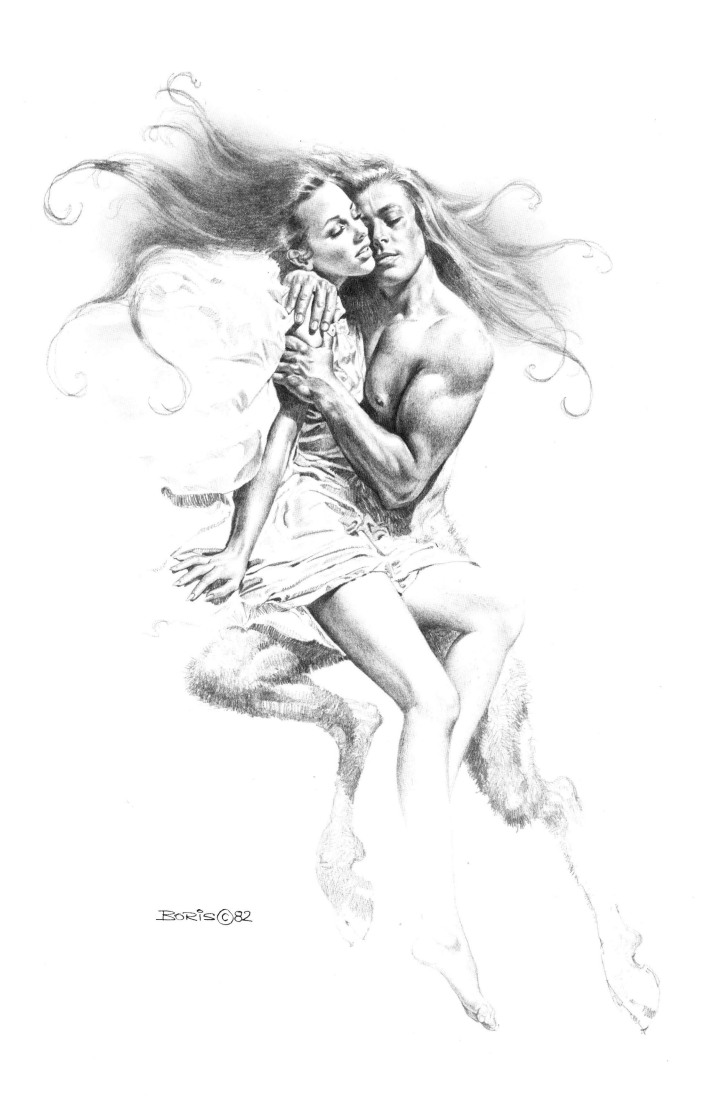

"Usually, what I manage to catch in a painting, finally, is only about fifty percent of what I had in mind initially. If I were to catch a hundred percent I would have to have a two-hundred percent image in my mind to begin with—if that makes any sense. It's like the scene from *Through the Looking Glass* in which Alice, breathless from running, is amazed to find that she is just at the spot where she started and the Red Queen tells her, '…if you want to get somewhere else, you must run at least twice as fast as that!'

"Knowing what I want to do is no guarantee that I'm going to do it. Possibly I will in a year, two years, five years if I persist; though by then I will undoubtedly have become more critical, more demanding. My horizon, so to speak, will have moved on. What I would have been satisfied with at one time will no longer be sufficient. That doesn't matter. It's just important to keep running and trying, figuratively, to go 'at least twice as fast.'

"My violin playing, for instance, has never progressed much past the point it was at when I left the conservatory because I too readily succumb to the frustration of not being as good as I want to be. I listen to a recording of—say—David Oistrakh and I think to myself: so, this is how it's supposed to sound. This is exactly how I want to play it. Then I take out my violin, play for a little while, tape my playing, settle back to listen to my own version of whatever it is, and be invariably surprised and appalled at the incredible difference between Oistrakh and me. Subsequently, as opposed to practicing the passages that give me difficulty, I put my violin back into its case and figure that there is no use bothering because I'm never going to get that good. Of course, I don't make my living playing the violin so it's hardly a tragedy. Essentially, though, I am robbing myself by refusing to suffer through what it takes to get significantly better. Most people, I find, don't want to suffer and thus stop short of fulfilling their dreams.

"Of course, it is a mistake to compare yourself with others. Why should I, in a few weeks time, play half as well, even a tenth as well as David Oistrakh who spent a lifetime at it; who, indeed, felt that one didn't just practice the violin, one lived with it. I live with painting. But I could improve as a violinist. Instead of dwelling on fruitless comparisons I could find satisfaction in my own improvement."

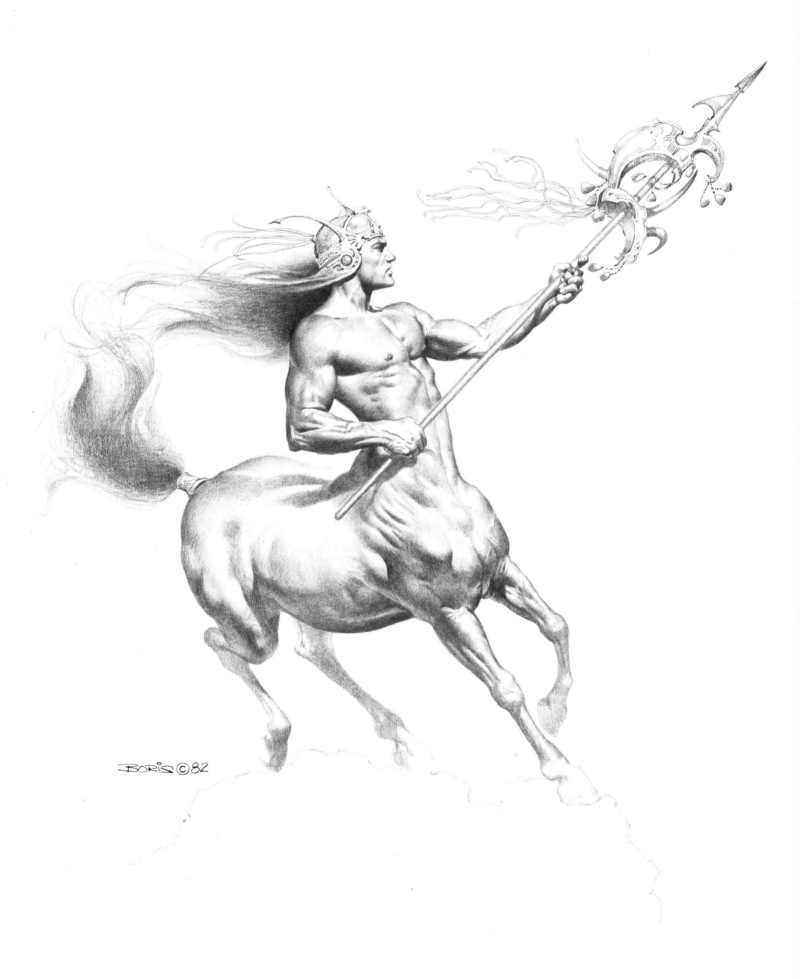

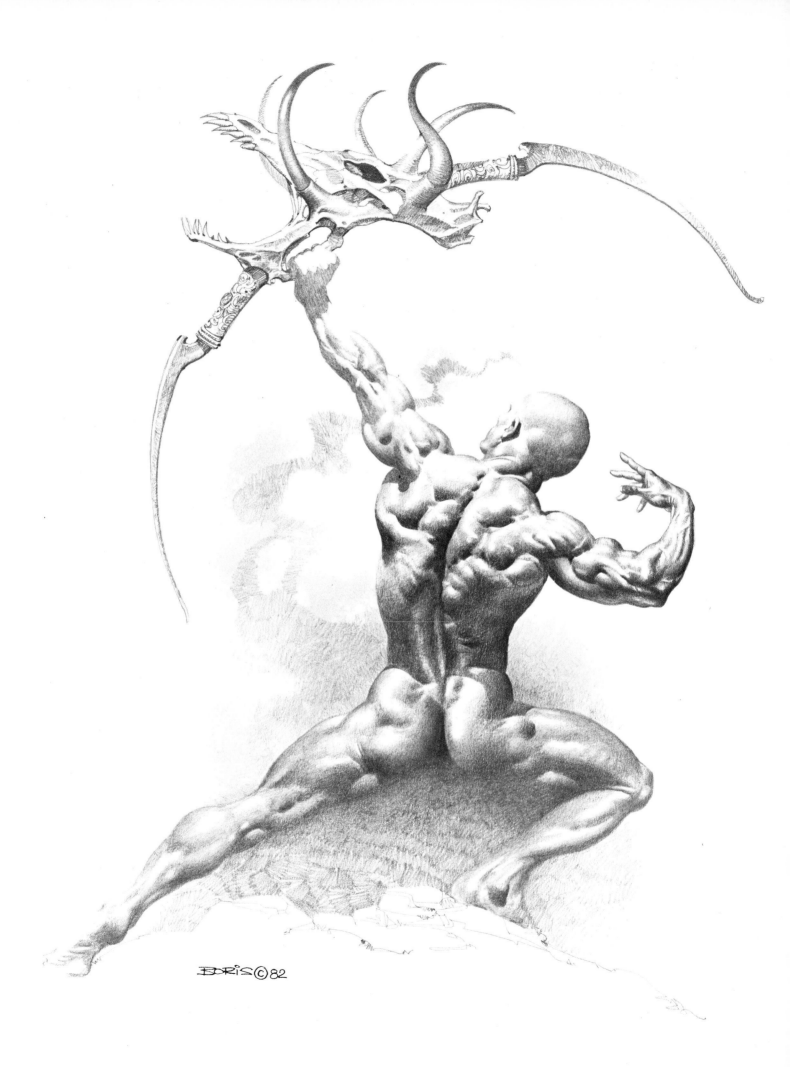

BORIS ©82

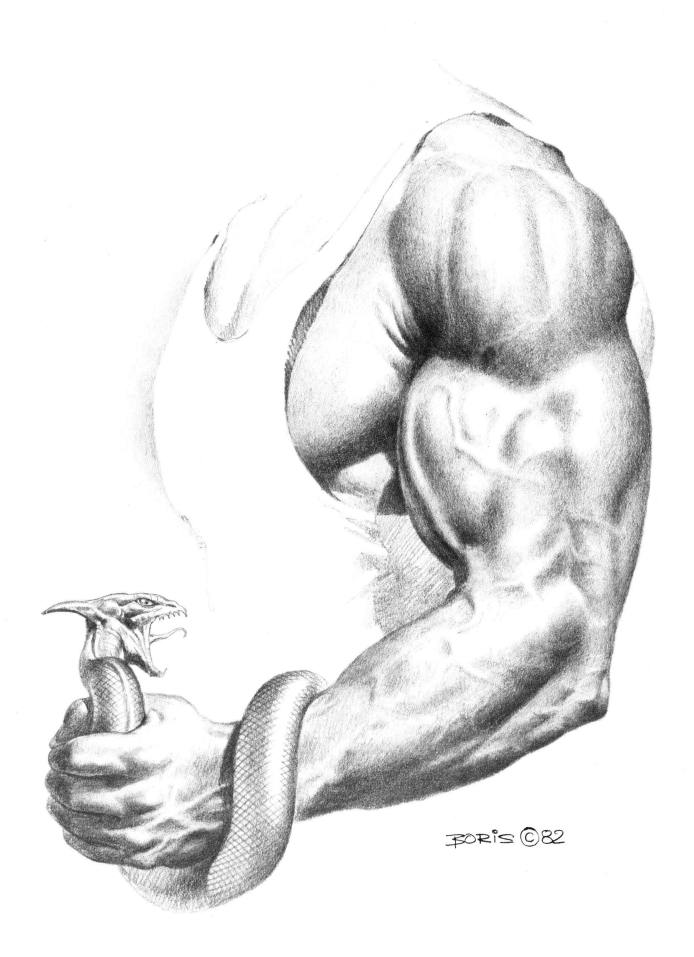

BORIS ©82

"To me painting is second nature, an integral part of living. And still it is always a struggle for me to begin a new painting. 'The fear of the empty canvas,' I have called it. It took me a while to realize what this actually was. I used to think it was entirely the apprehension about being able to fulfill my own expectations. And there is some of that. But what happens on a more direct level is that I am simply bored with the preliminary steps. Preparing the board, sketching the figures, doing the underpainting—all that is immensely tedious to me. For me the joy of painting is painting.

"I would paint even if I didn't have to earn a living, although basically I do prefer not working to working. But I love painting. I love to see paintings—anybody's —as long as they are good, which is why I spend as much money as I do on books of paintings. I would go as far as saying: I love to see—whether I am seeing men, women, children, animals. I am tremendously visual. And, consequently, I love to see the reinterpretation of what I have seen taking shape under my own hands.

"I still enjoy looking at the paintings I have done a while ago. Some, of course, I am more fond of than others. The subject matter of the painting doesn't determine how I feel about it but, rather, how I have handled certain things. I can be in love with certain areas of a painting. In *Jungle,* for instance, I love that leather jacket: the folds, the shine—I can actually feel it. Everything is right there. And I love the head of that monster. I really enjoy his expression, his ugliness as well as the little details of the veins and the different colors. I can almost hear the screech of that monster. And this, to me, is exciting.

"I can't plan these things ahead of time. Much of my painting is instinctive. Things happen as I work. As I worked on the monster, on his open mouth, I began, as I said, almost to hear him. As I was doing the veins in his head I could feel the texture of the skin stretched over them. But I had none of that in mind when I began. It wasn't the result of any cerebral plotting. I don't mean to imply that it didn't come from within me— the feel of skin, of leather, the monster's screech. But the translating of it into art was not an intellectual act.

"What I do consciously aim for in painting is, more than anything else, to create a visual impact. And, to me, figure is the ultimate test; to be able to hold the viewer in thrall without relying on excessive detail or a whole crowd scene—this is excellence in painting. Whatever happens on the canvas that goes beyond this springs from my subconscious. It isn't planned.

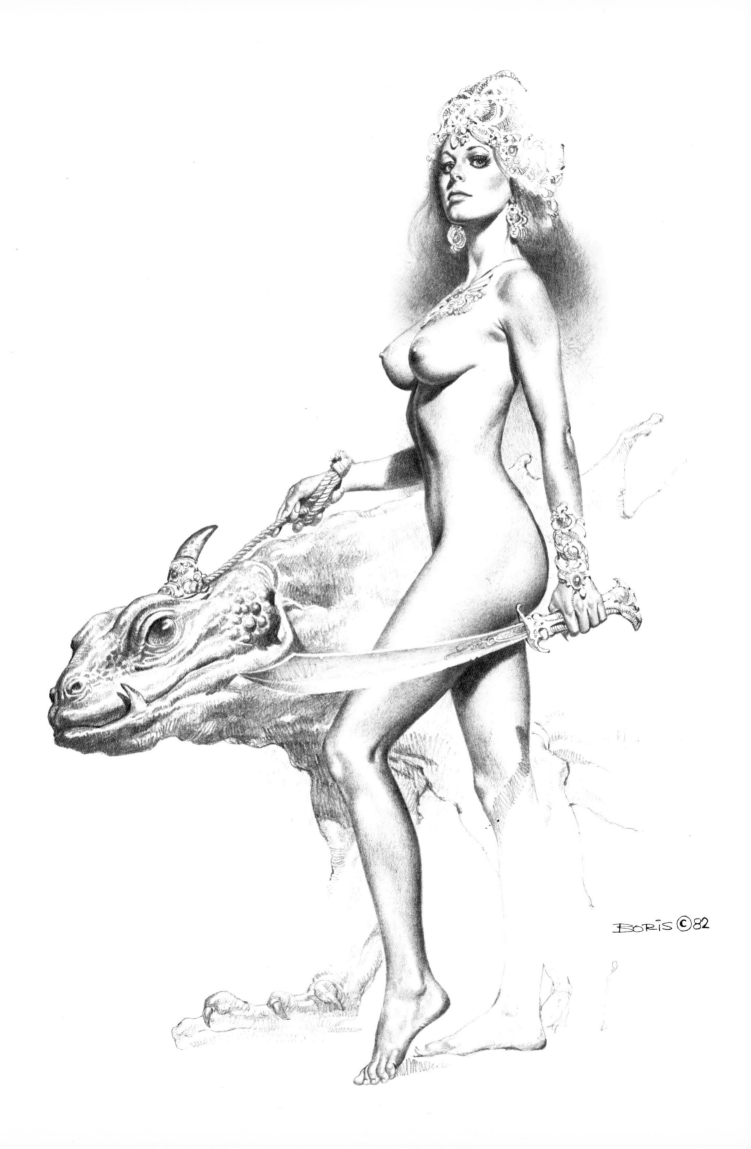

"If you were to say about the paintings in this book, 'Tell me, what does this one or that one mean to you'—I'd have to start thinking about it. What I began with, what I tried to create on canvas was a vision: an image that I have seen with profound clarity in my mind. No more, no less. No *message* as such.

"Of course my imagery has some intrinsic meaning. It doesn't arise out of a void. I like to draw the comparison between this and a computer into which you feed a problem and from which, in a matter of seconds, you receive an answer. Now, an elaborate process unquestionably took place in the space of those few seconds. Were I a scientist I might be interested in that process. As an artist, however, I am only interested in the answer.

"When I see a beautiful woman in the street I enjoy looking at her. Do I start imagining how it would feel to touch her? What it would be like to make love to her? Not at all, though some of that may find expression in a painting sometime. Still, at the moment, I just enjoy what I *see.*"

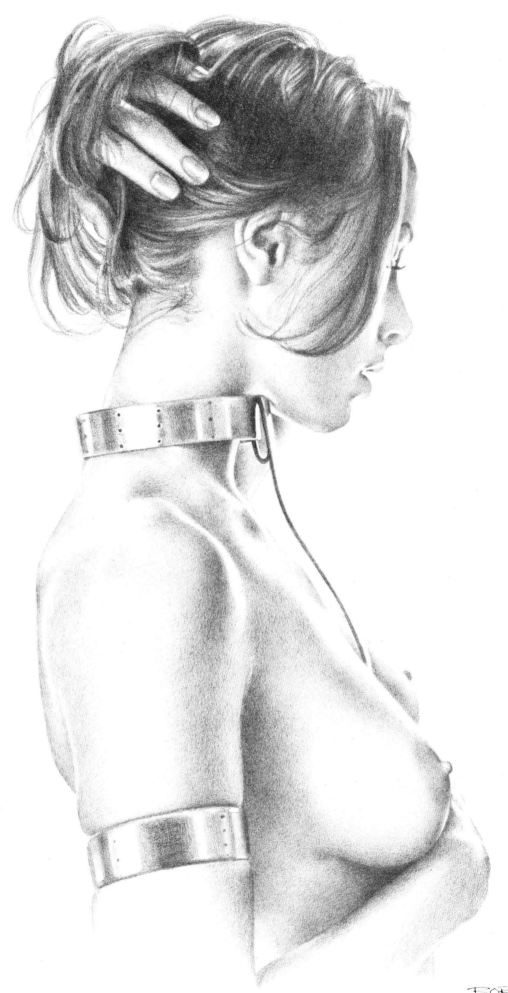

MIRAGE

Night
clings to his kiss.

He will take me,
wound in leathery wings,
high over the plastic houses
where men and women
disentangled
lie like mismatched dolls,
the morning after taste of disenchantment
collecting tartly
in their mouths.

I long to fly
but, moment to moment
must cling to him
to remember longing, to
renew belief,
to assuage the terror
of flight.

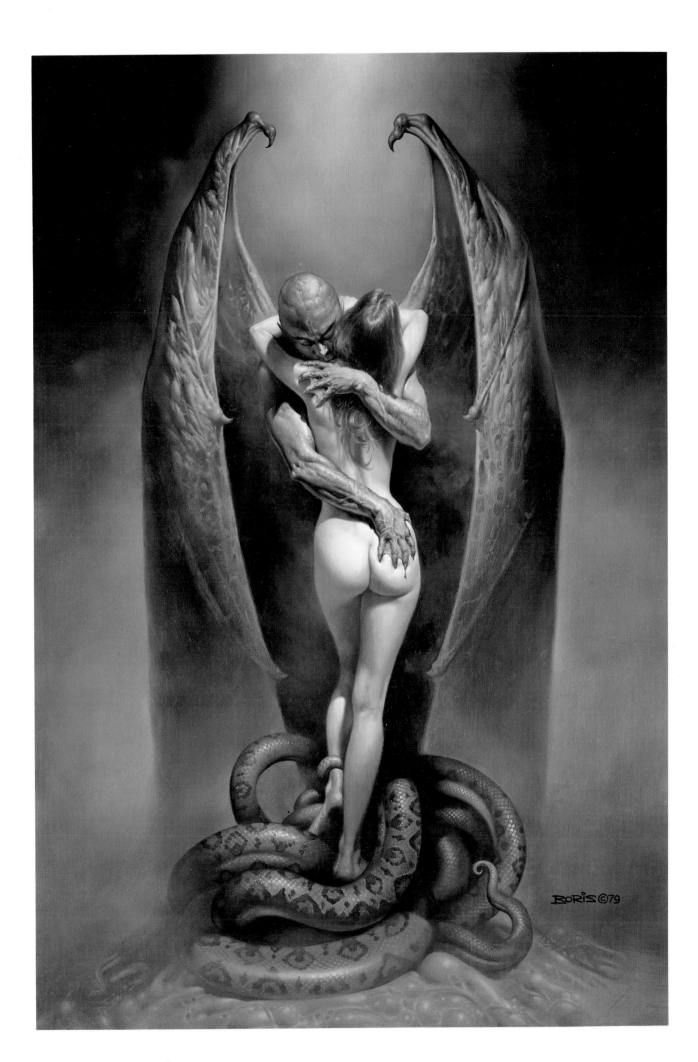

Born
to a spasm's beat,
muscled out
through a grunt's
release
I strain to rise,
to fly,
to cry those tears
that teach new lungs to breathe.

But I am anchored
to the beast,
caught
in the cramp of its moist embrace.

What if its open jaws
convulse?
Its teeth,
those gilded ivory stakes,
would ream
my heart.

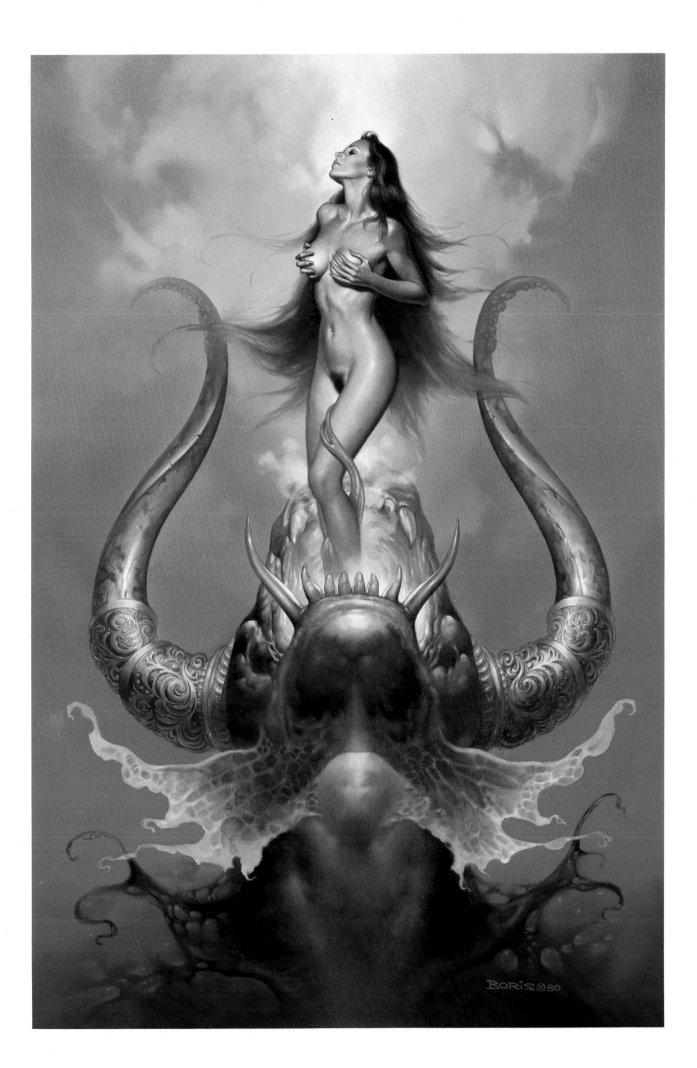

She waits
in imagined love's perfection
for him to alight
like a blown kiss,
for the tips of his toes
to imprint
the sand
before he kneels
and flows
against her
like the sea.

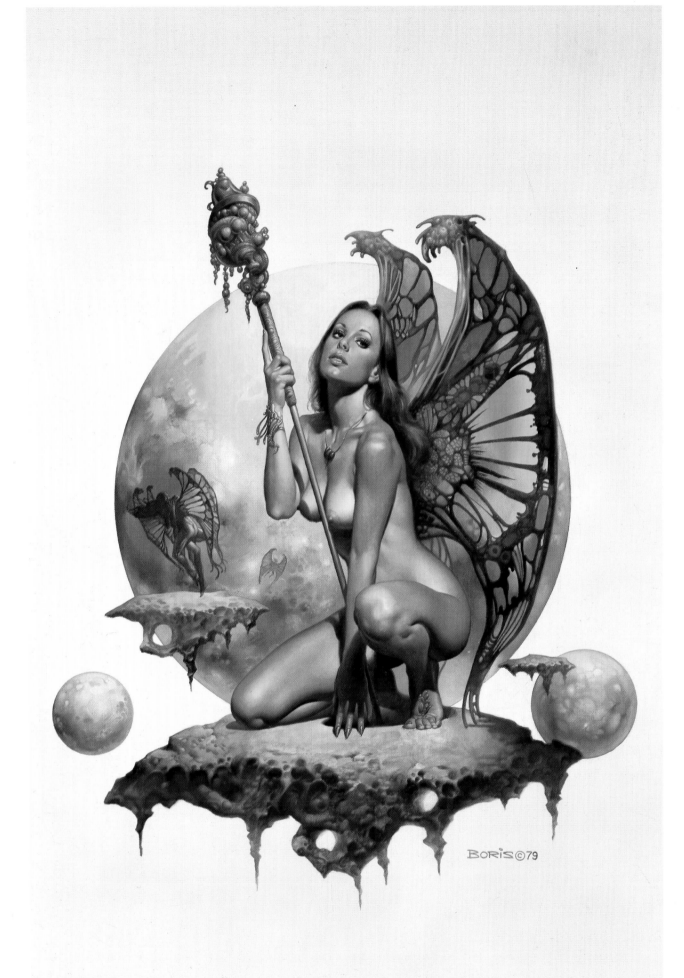

What savage promises you spin
that I may batter
happiness
against the rock
cold
dreaming
of your kiss
and know
of soaring
without eagle wings
drumming
the sultry air.

Enchantress,
clinging
dagger-clawed
to slippery cliffs,
I hear you
calling
across the wind loved sea.

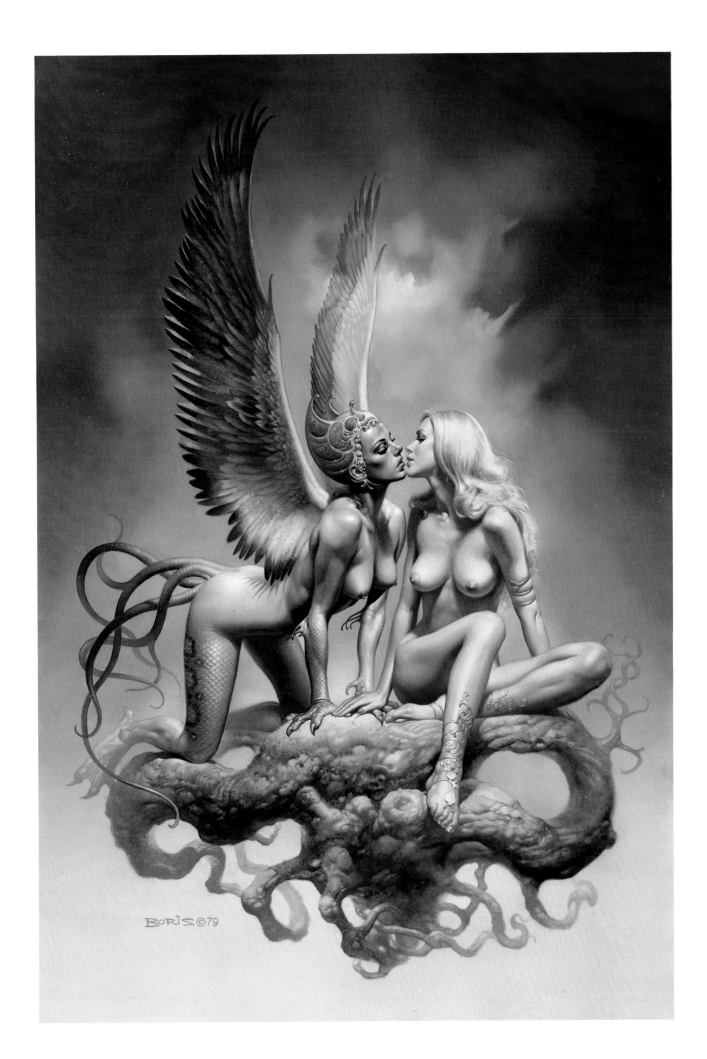

Perfect instants:
fervent, fleeting, pungent
wisps of time
dispelled by touch.

The instant
of winding;
of warmth at the core
curling and swelling.

The instant
of being wound
in smooth, sliding, hardening coils.

The instant
of roused flesh
ruffled,
magnetized.

The instant
of unwinding
what was wound.

The instant
of dreaming
before the dream flies
on lilac-sheer ephemeral wings.

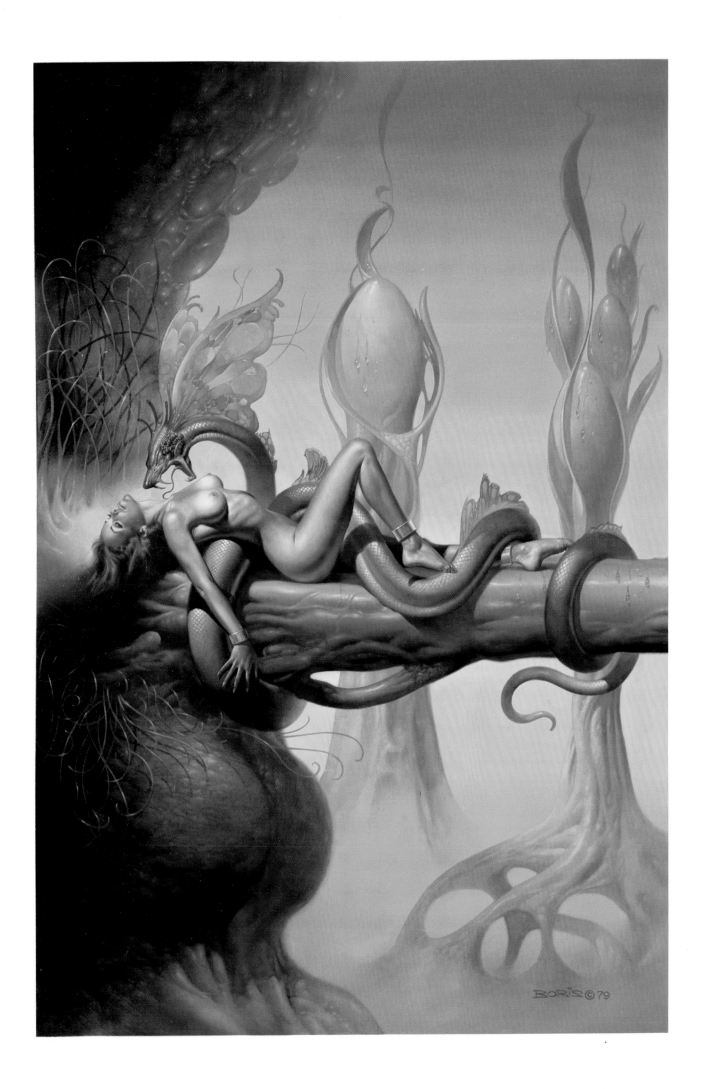

Time contracts
between us
across the frigid snow
thawed by our heat.

Longing swells.
Tides of blood
thrum
in quickening beats.

Etched in moonlight
we measure
silence
nimbly spanned in a leap.

Tomorrow
nothing will remain
but frozen prints
of paws and feet.

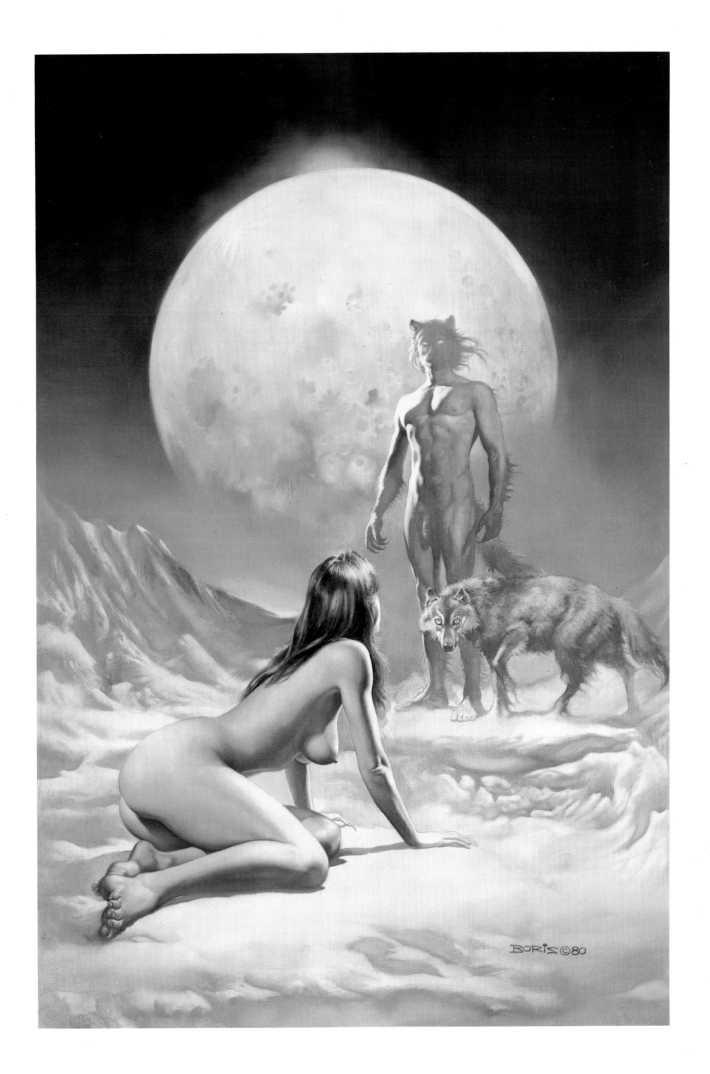

Sunbeams steal through my garden,
leaving the tell tale footprints
of buds lazily swelling
into flowers.

Sunbeams
cruise among grassy shadows
alive with wordless cries;
beating wings an incantation
against your slowly wakening eyes.

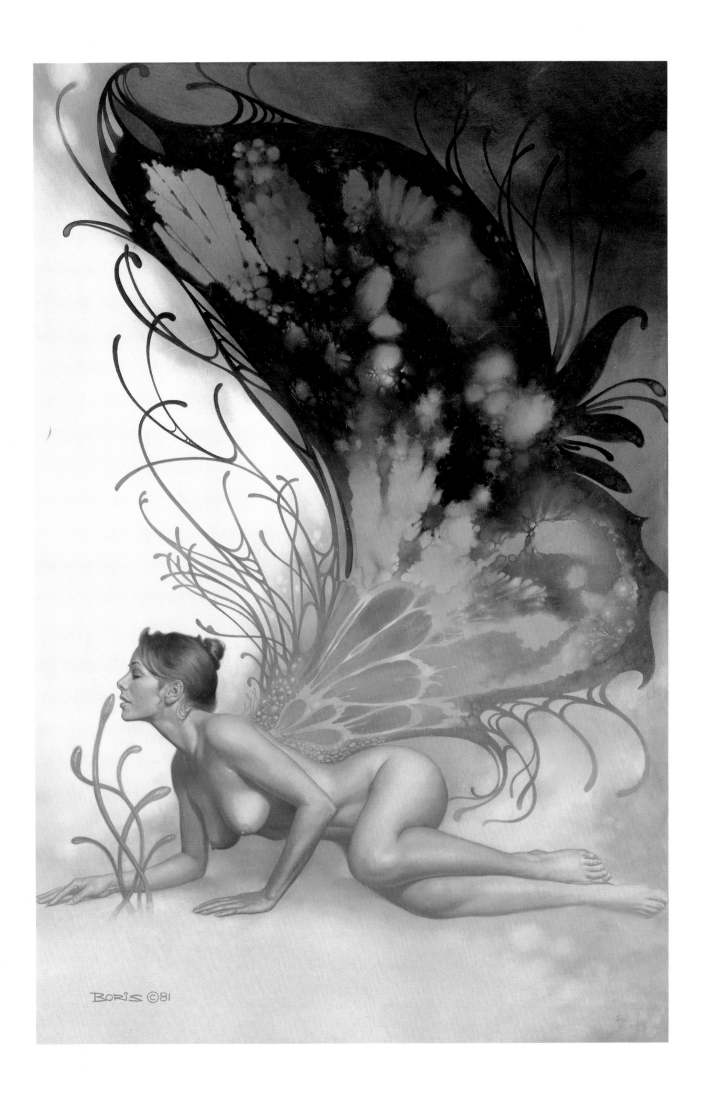

BORIS ©81

Follow forever moments
among sun touched hills
though caresses offer no eternities.

Though there are no mortal angels
I hear the music of your perfumed wings
and the silence of your kisses
gently playing.

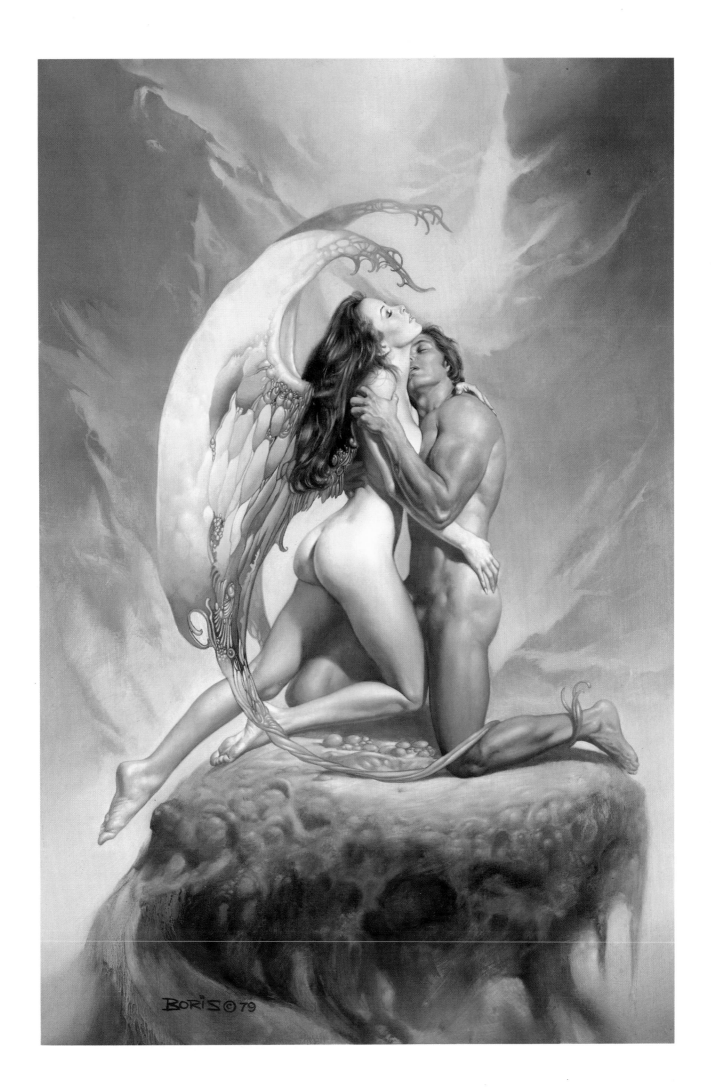

I imagine
 I am your first love.

I dreamed you
 embryo,
 butterfly,
 miracle.

Held you,
 rainbowing bubble,
 perfectly balanced
 on my hand.

Discovered you,
 sheltered you from cold mists,
 nurtured you on the nectar of passion flowers,
 showed you the gold in sunbeams,
 the silver in fragile wings.

And who discovered me?
 Imbued me with wishes?
From the palm of whose hand
 did I take flight?

I have almost forgotten
 my first love.
What remains is a sweetness
 stung with tears.

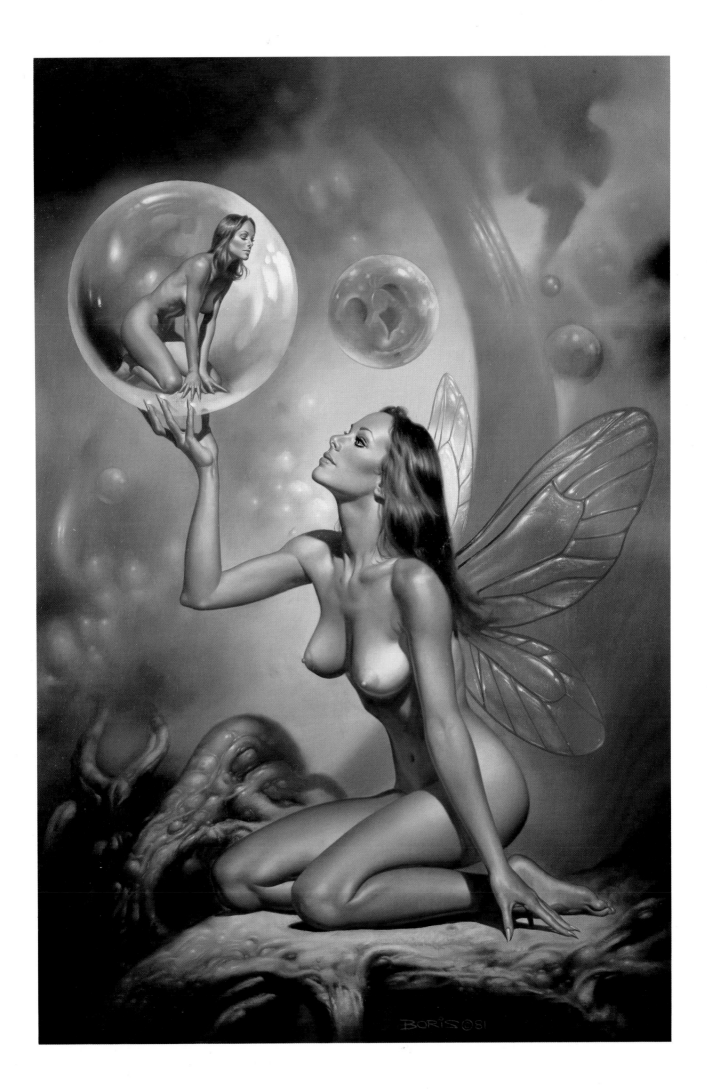

The breathless silences between your touches
smolder
in the reflected fire light of your kiss.

The fevered salt-stench of your body
burns me
yet, I've no will to flee.

No wish for cooling
empty air
to ease me.

No need for antidotes
against
your sting.

Don't stop! Don't stop
lest I die
sucking, shrieking at you

from all the entrances
and exits
you have made.

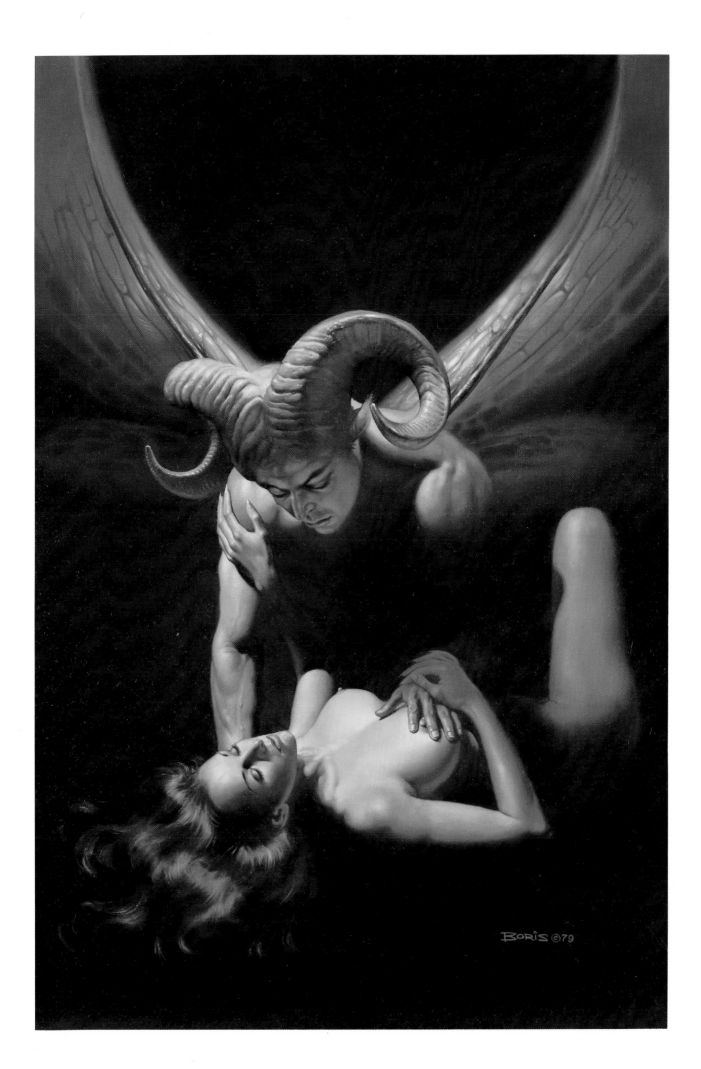

Little counterfeit lover,
 how were you born out of milk-white, warm-white
 vanishing bubbles?

How, cast from a half dreamed memory,
 do you understand the tick-tock
 of a ravenous heart?

And how, from your half imagined mouth,
 do you blow wet foamy kisses
 light as touches
 begun and ended
 yesterday?

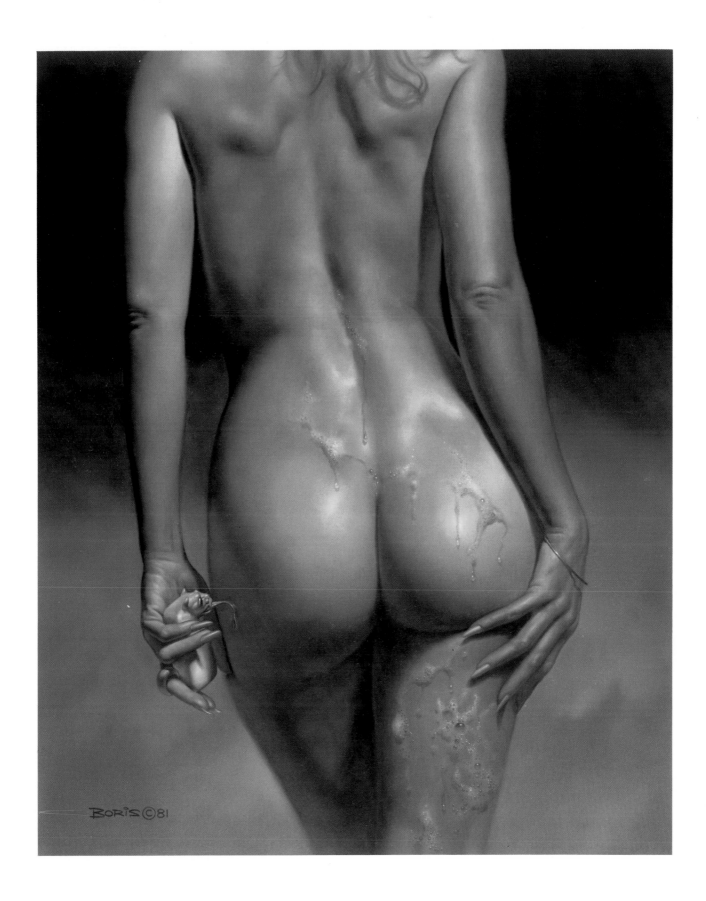

No eyes are completely empty.
Even her eyes,
 bright
 and cold as brass rivets,
 reflect
 wasteland longings
 and call
 though their echo is silence.

She rides her toad-skinned Cerberus
across a shadowed Earth
and dreams
 of lovers
 reeling
 from her carnivorous kisses.

Dreams
 of rising,
 a scarecrow angel.

Dreams
 of flying,
 blood-gorged,
 forever
 toward midnight
 horizons.

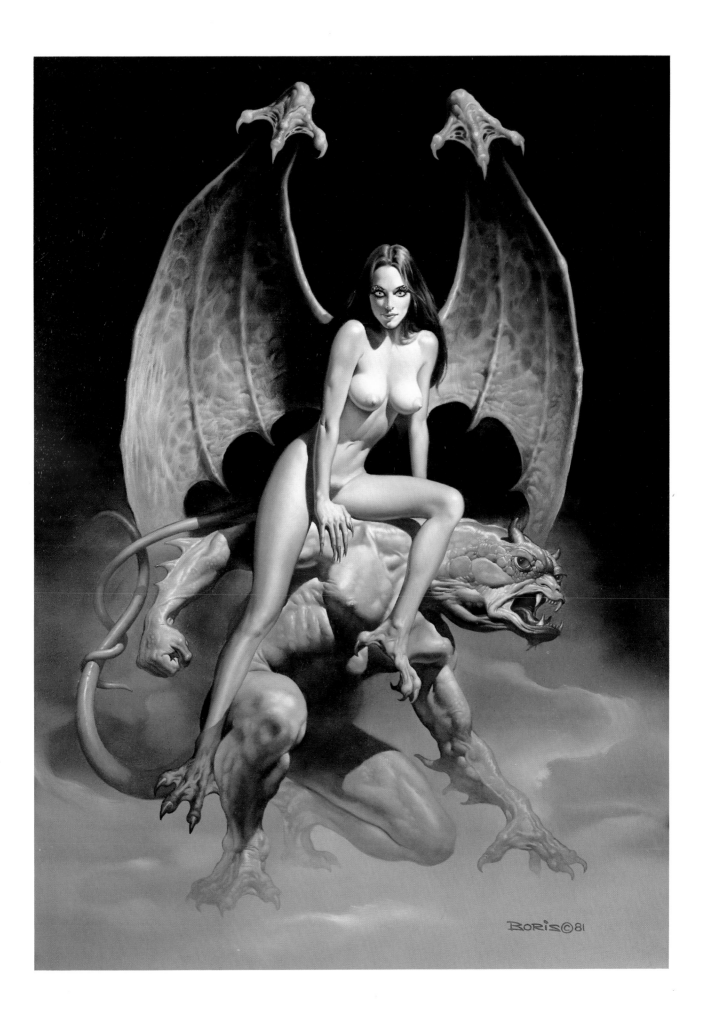

BORIS ©81

You startle the sunset with hurricane cries
and drown the chirrup of terrestrial things
with the slap and snap of wings
pungent with sea water.

Where are you going wraith riders?

To hold back the billowing dark with your fiery reveilles?
Your thunderclap heartbeats whip crack
against the rising tide
of silences.

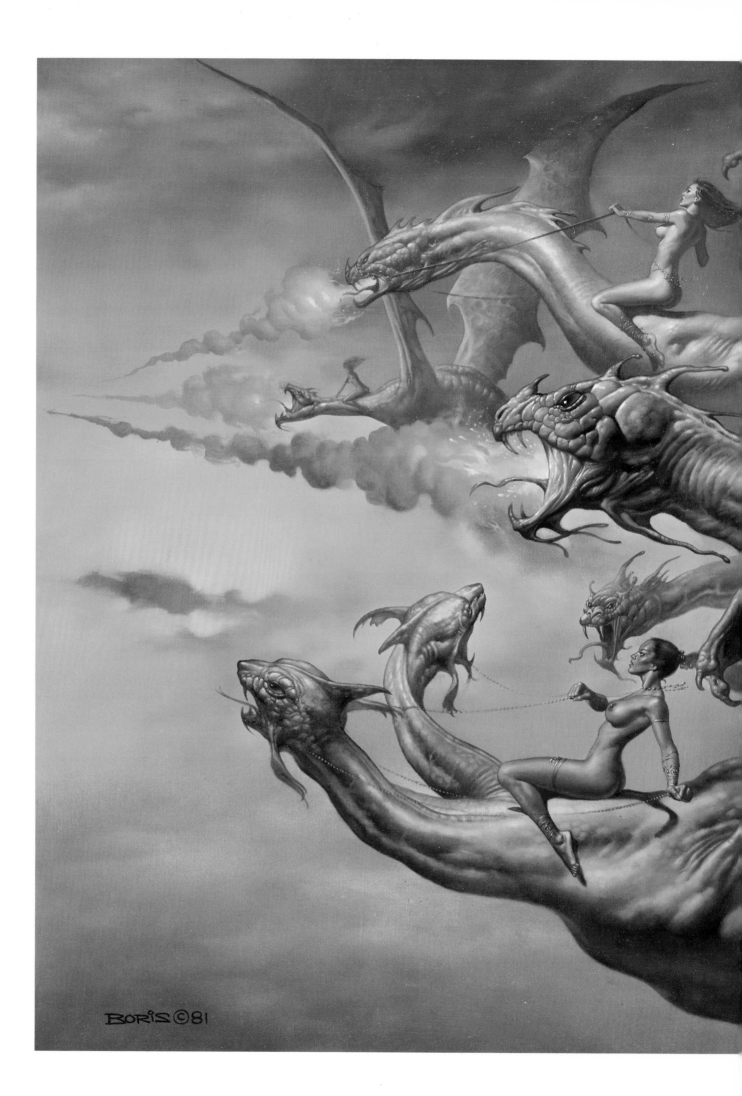

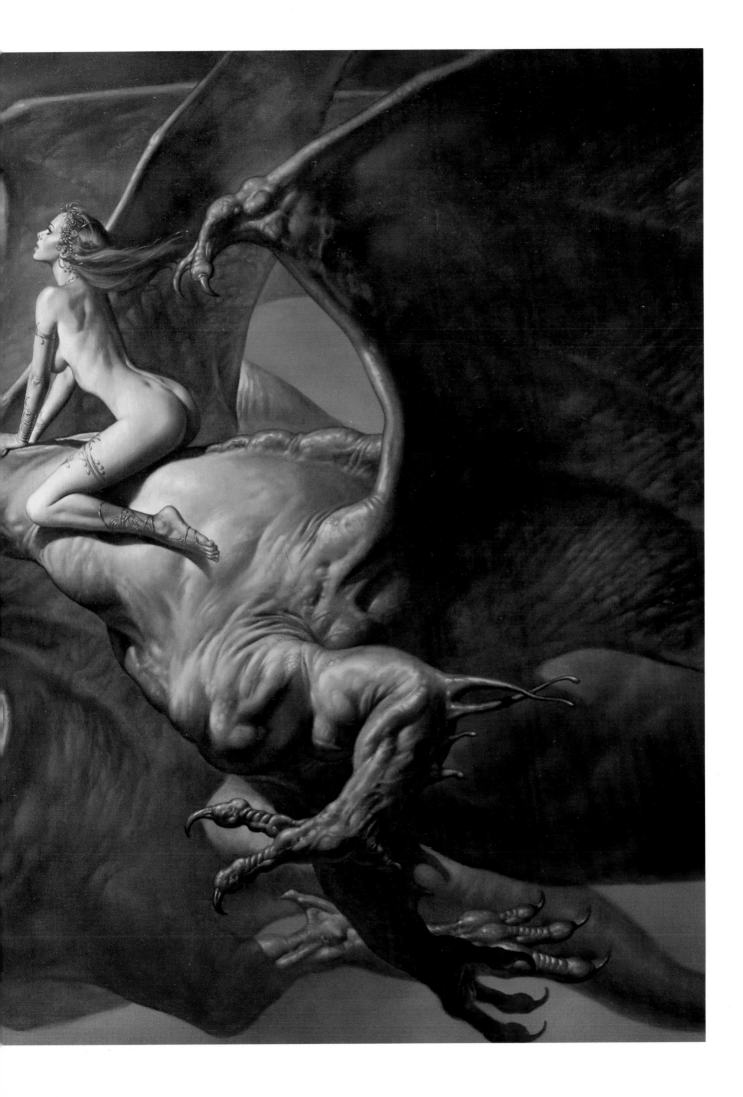

At a masquerade
I met a serpent
dressed as a woman
I once loved.

"I know you," I said,
"mirage in the desert.
Your breasts are sand dunes
that will flow through my hands."

Her hypnotic gaze
made me thirsty.
I crawled
panting
toward the tears in her eyes
just to discover
they were tears of laughter
reflecting my face
as a hundred masks.

"Stay with me little love mite,"
she chanted.
"The sun is setting,
it is getting dark.
At midnight disguises all fall to ashes.
Then we'll grapple
unhampered
in each other's coils."

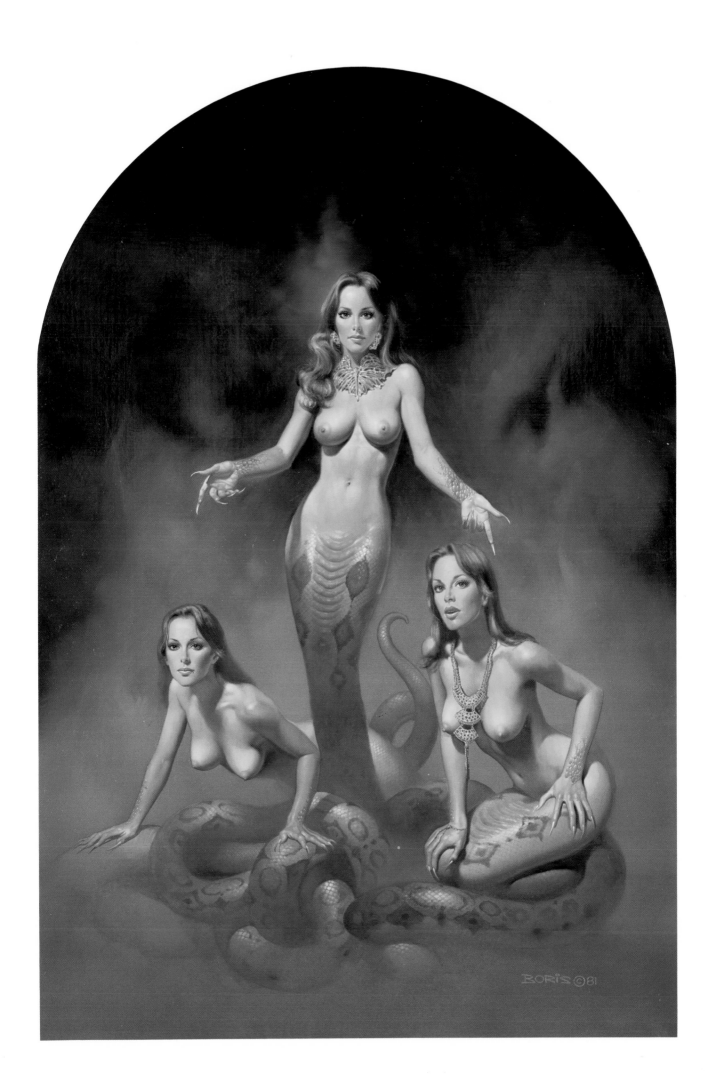

Flight:
Light-blinded longing
to touch the sun.
Hurtling
toward its volcanic embrace.

Soaring:
A galloping uproar of heartbeats
toward that antic splendor
of burning clouds
and unimaginable painted gardens.

Reaching:
Higher, higher
in fierce, lengthening
wind-kisses
of blood.

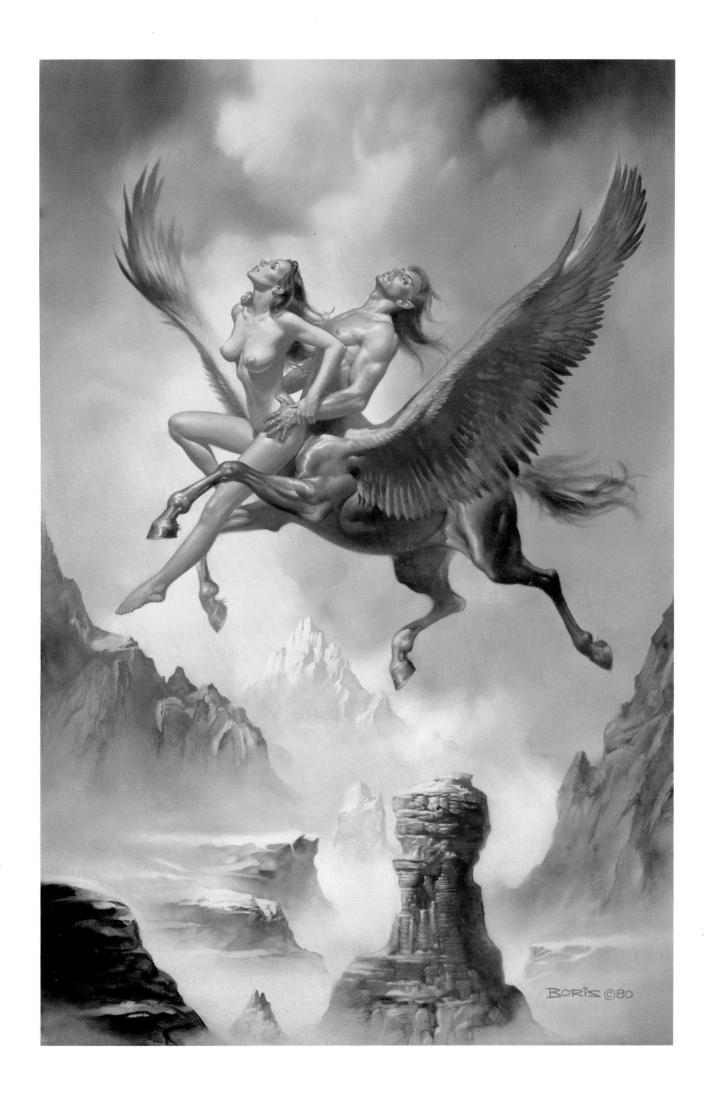

Your twilight fills with unsuspecting lovers
that cry:
I am the one!
and quiver in your strangling web
not knowing
that for you there is no ONE
but just one more.

You wait,
dark spider of the heart,
and spin your traps of dream light
knowing
anguish
is lunatic hope.
Knowing
none can flee the struggle.
Knowing
each diminished breath
pleads
for your last sting.

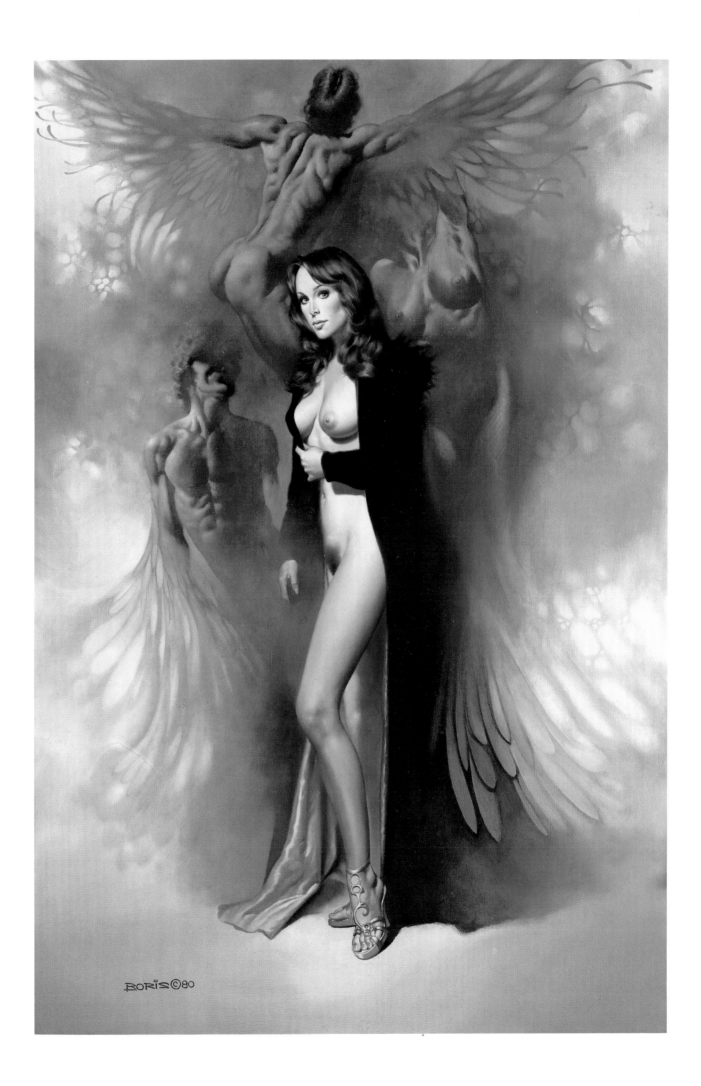

Drinkers
 linked
 drought by drought
 suck honeyed sap from
 the tangling of limbs and branches:
 that Gordian knot
 which will not loosen
 until an obsolete tomorrow
 dryly dawns.

Locked
 breath to heated breath
 they know the howl of winds
 along their naked boughs:
 the harmonies of bending,
 bending, bending
 before the unremembered
 break and crash.

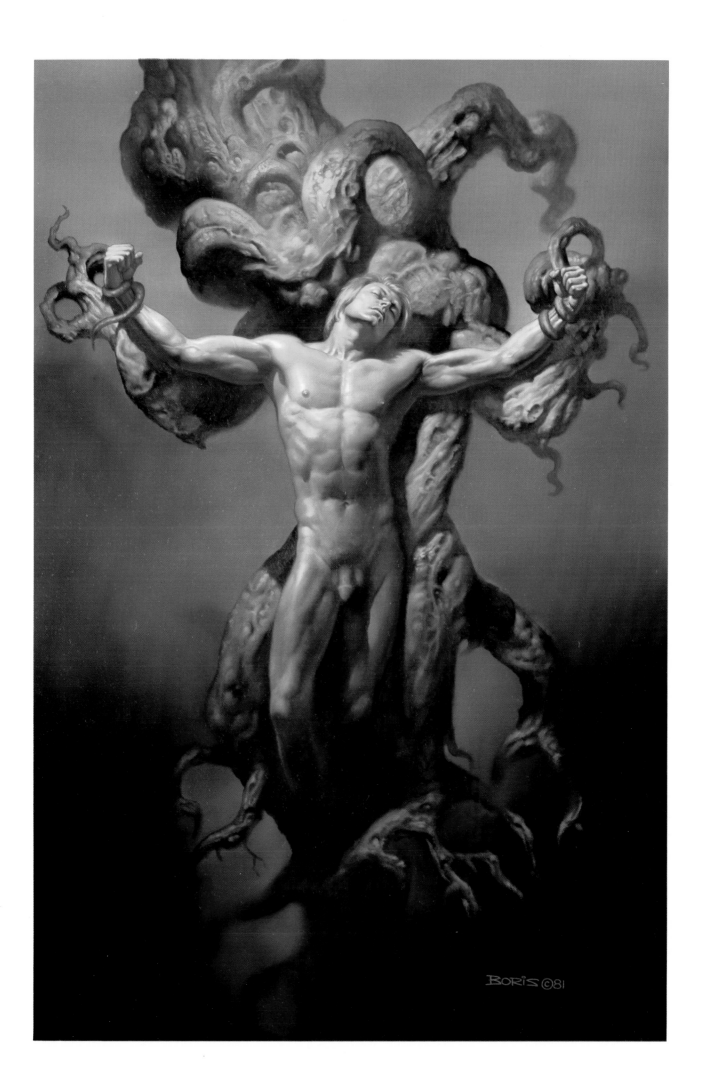

I perch
 on the moment's edge
singing
 a song that echoes
 and ruffles shadows
 in the dream-dark plumage
 of my dream-bright bird.

 Caught dreaming
 by the harsh embrace
 of clawed feet
 I sigh.

Dreaming
 of the rapacious mouth
I cry
 at the tongue-tip touch
 that looses
 cascade glides
 to wakening.

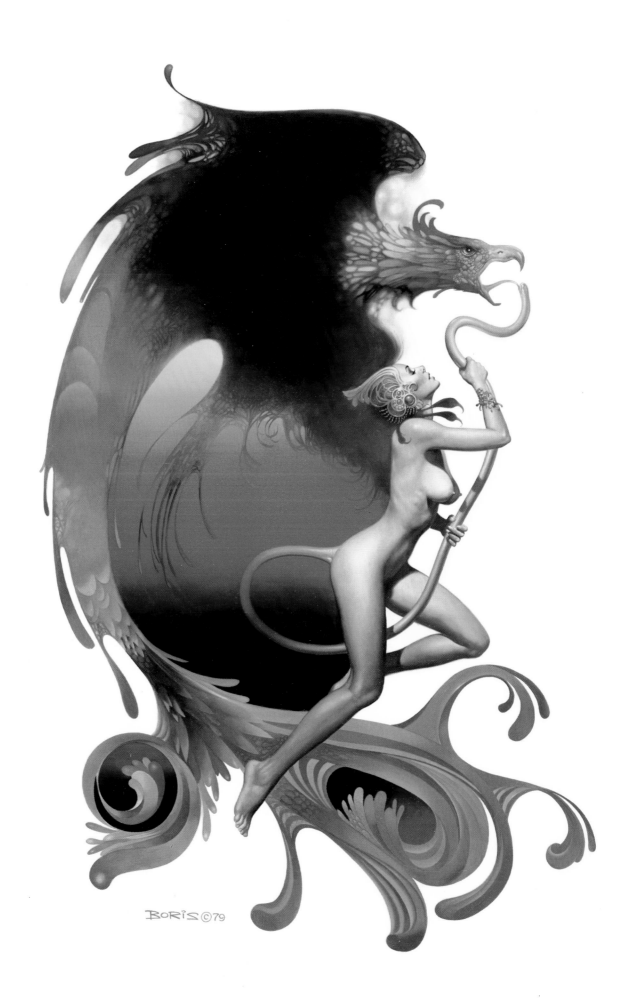

BORIS ©79

He rocks me,
cradled in poppy mist,
while I suck from his gold umbilical tongue
such dreams
as lope and tumble through his blood.

Cloud-drift lovers meet,
dissolve in each other
and sigh,
spilling secrets at the edge of always
before my sleep-wakened eyes.

Inhale his dreaming breath and flee
a dawn
empty
as an amnesiac's smile.

Drown in his dreaming breath
to flee
a dusk
sallow
as dead chrysanthemums.

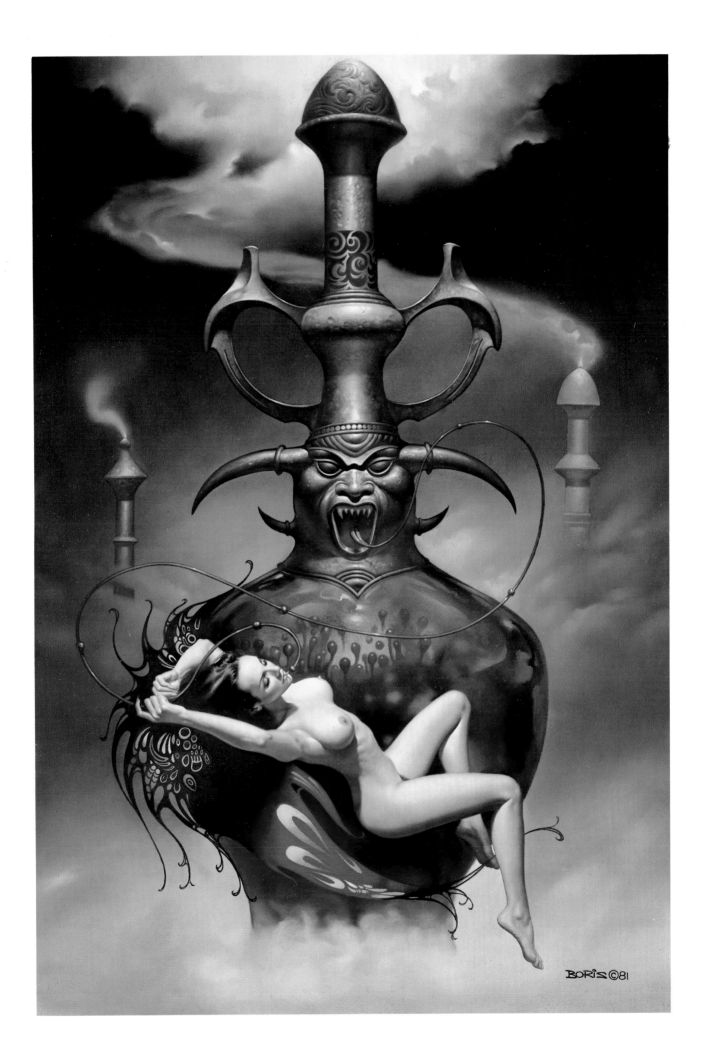

The Jade Manikin lived practically under my skin,
happily,
or so I thought
until he pinched me.

I pulled him out like a lizard from under a root,
plucked him out,
spit him out
along with the cruel taste of his cry.

Yet
I want to sing him lullabies,
rock him between my thighs,
tie him into a knot with my tongue,
carve his sharp moods along gentler lines,
resculpt him
so there will be no empty space
between his skin and mine.

I would dazzle him with treats.
I would be a pink satin banana split
for him to eat.
But he stamps his little feet
and says
banana splits (and related feasts)
are sickeningly sweet.

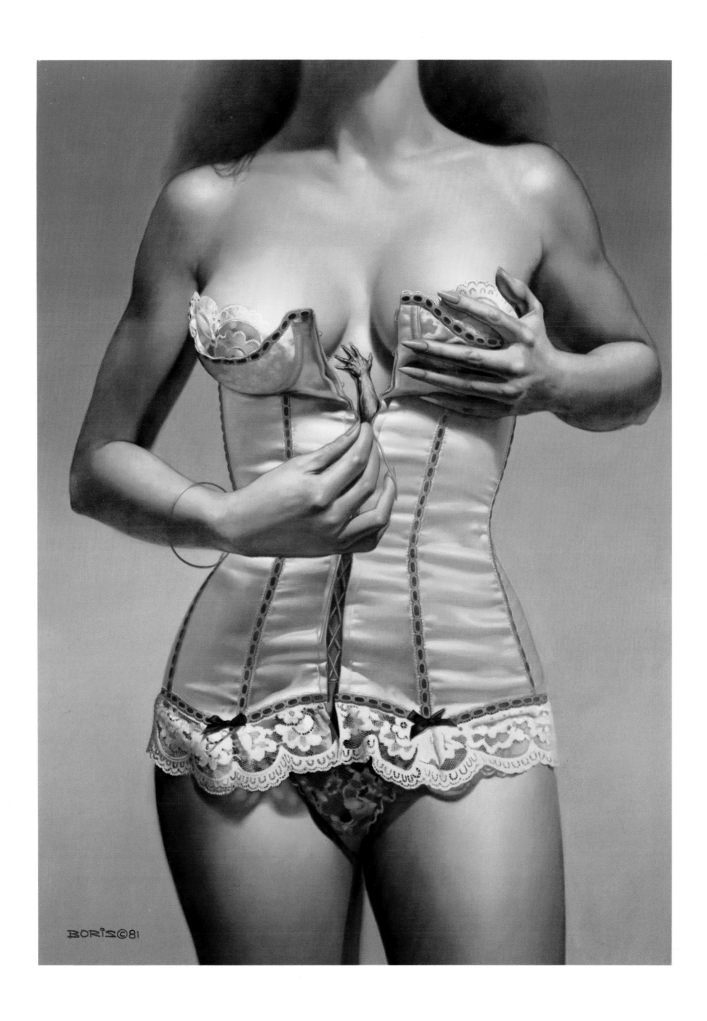

I know you:
 elf
 witch
 wonderwoman.

Darkness
 and pearl-gray, ash-gray flesh that sifts
 (as silken ashes) to the touch.

Once
a silence inside you
 burst
 and blazingly
 effaced the night.

Your death and birth cries fill the universe
 with echoes.
Your fire will (eons hence)
 become a star
that lovers may chance to wish upon
 on dark nights.
All yearning
 is a sanguine thrust
 toward light.

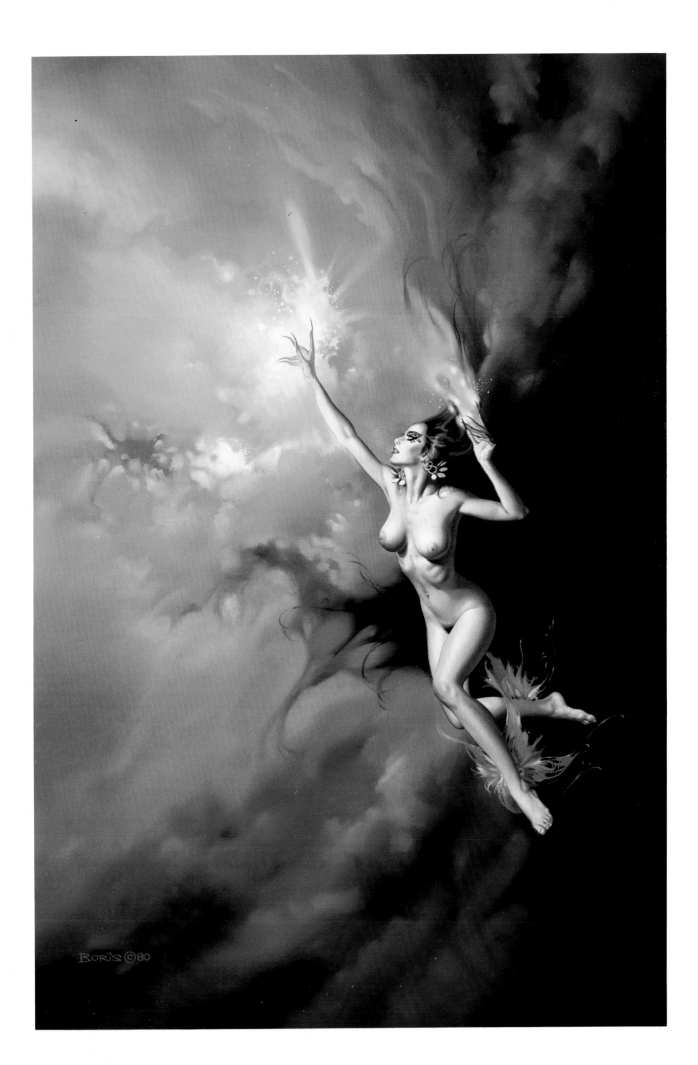

In the flesh-locked land of longing
mute hands comb the whining bone marrow
for a short way home.

Touches shine brighter than words or IOUs
in the dark
and can neither be counted like pennies
nor used to anchor a dead man's eyes.

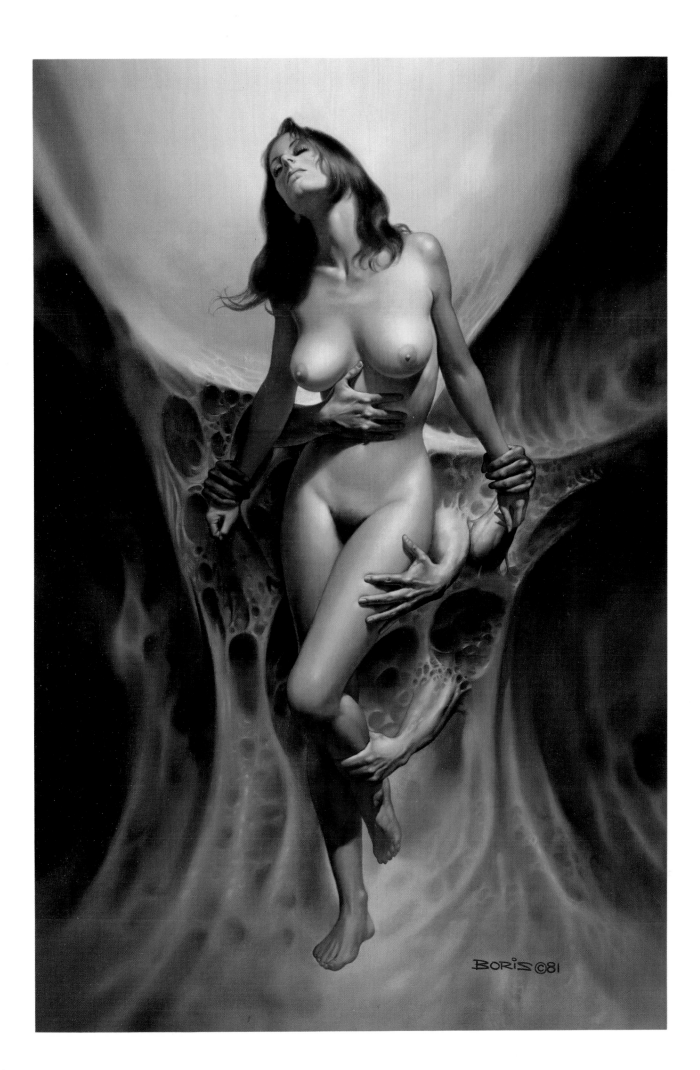

His call:
a jungle of red-ragged roars!
And promises
hard as torpedoes,
hot as cannon balls,
dazzling as a kiss-polished hide.

Listen:
Claws tattoo throbs
　　in the shadow of twin suns.
Fires flash
　　from an opened wound.
Joy tears like alarm
　　through tremulous ground.
A thick tail drums
　　on silk-fine flesh.

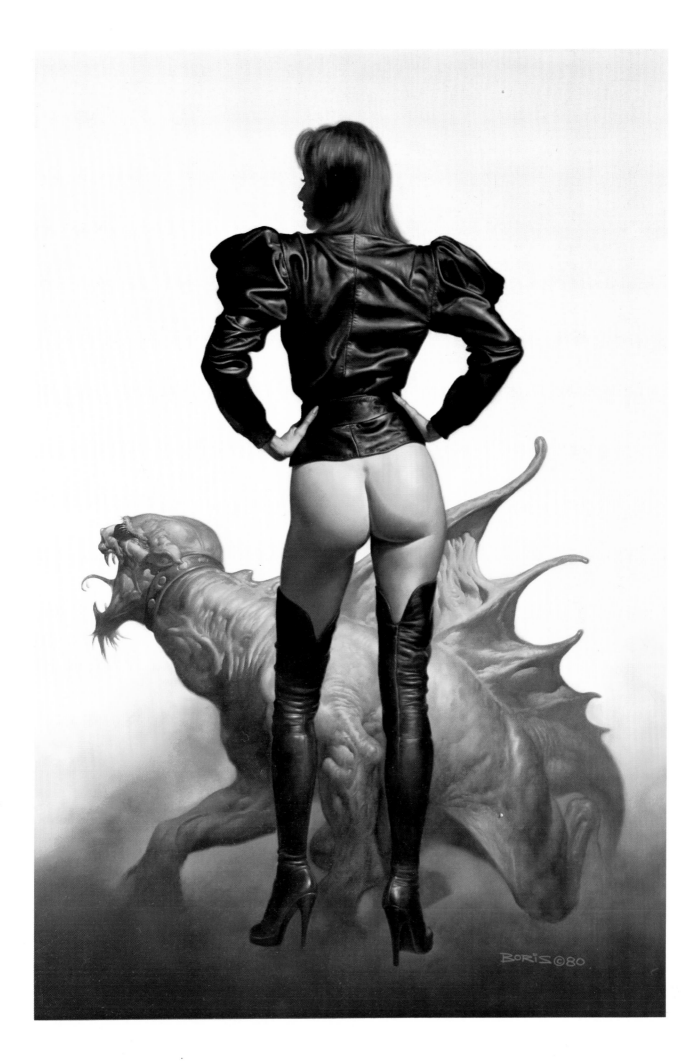

The sea is filled with madmen
 weary of mermaids, seaweed
 and the changelessness
 of salt in their eyes.

They weave a bride out of sunbeams
 and sea gull feathers
 to hold in their webbed hands.

Vulcanic splendor, fire, mist,
 she slips through their fingertips,
 light and sharp as air bubbles in the veins.
 Icicle tears congeal her smile.

Shoreless bridegrooms
 treading the frenzied waves,
 clutch at a wedding gown of foam
 and wail like shipwrecked sailors
 against the dissolution of dreams.

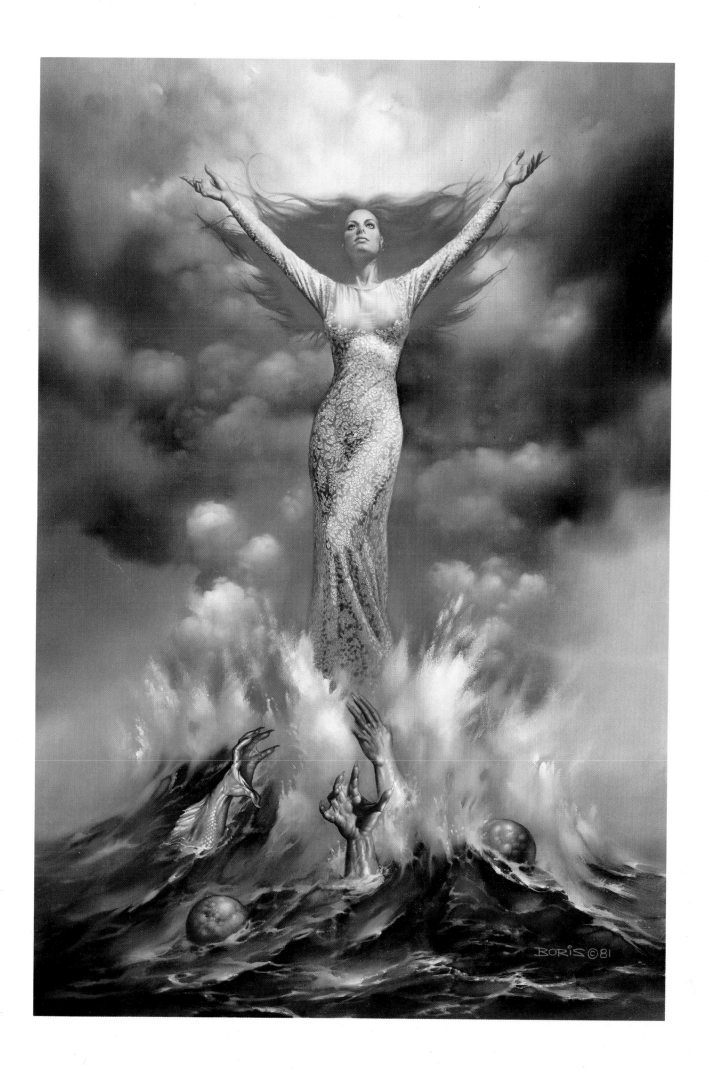

I am alone,
rainbows billow in my head.
I sink
and rise
tide-torn
to find

I am a mermaid
though I have two legs
and, between them,
what dreams may thrash?
What maddened loves
may be tossed
or lost?

I am a beast
mounted by beasts,
swollen-muscled,
purposeful,
hard
till the breaking time comes
and we slip apart.

I am the moon,
pale, soft,
helpless
to halt the invasion
of my shadows.

I am the sun,
hot, bright
with a torturous thirst
for the moon's
misted canyons.

I am mute
flesh
that the stroking
of fingers
can bring
to sing.

I am alone.

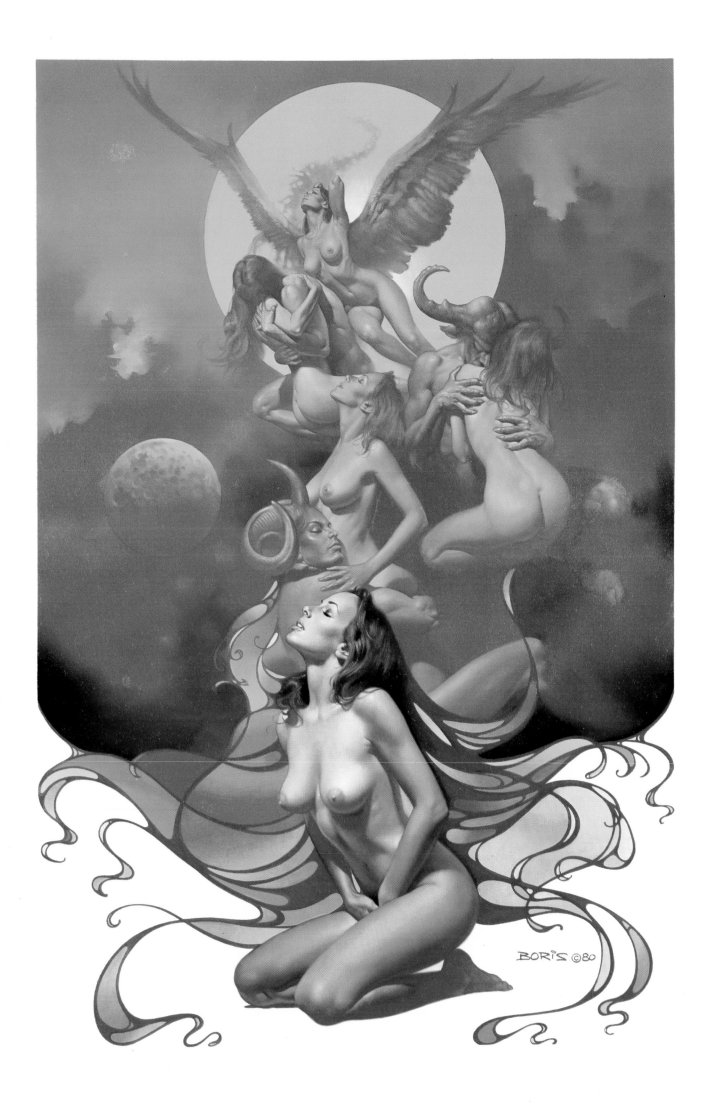

Eloquent human hands would I give you
and lips tasting faintly of flower petals.
But your eyes, bright as laughter,
I would leave as they are
to sing
their clear high transient notes
before the crack
of a dead tree
alarms you
and your bounding splashing flight
is only echoed
in the faint tremble
of lily leaves.

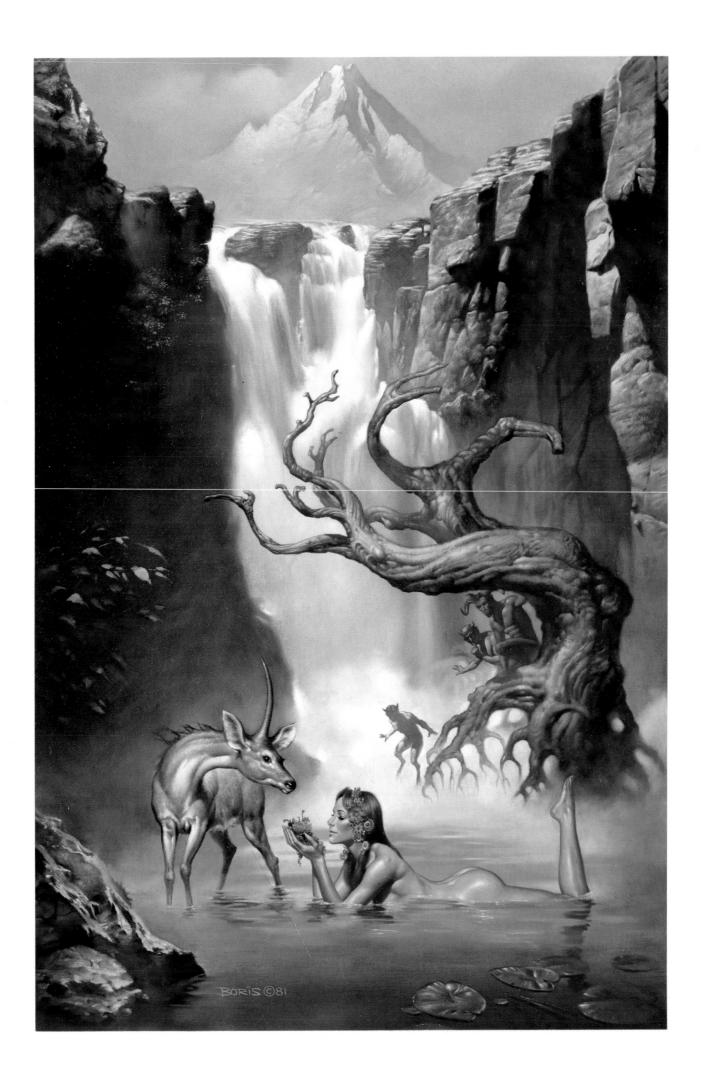

The hydra will feed on my shadow no more
 nor slither wetly between eyelid and eye
 where I can't refuse to see him.

Between the laughter and the cry
 I hacked his heads off.
Though his blood ran fresh
 his wounds crackled:
 dry,
 the protesting stumps of amputated wishes.

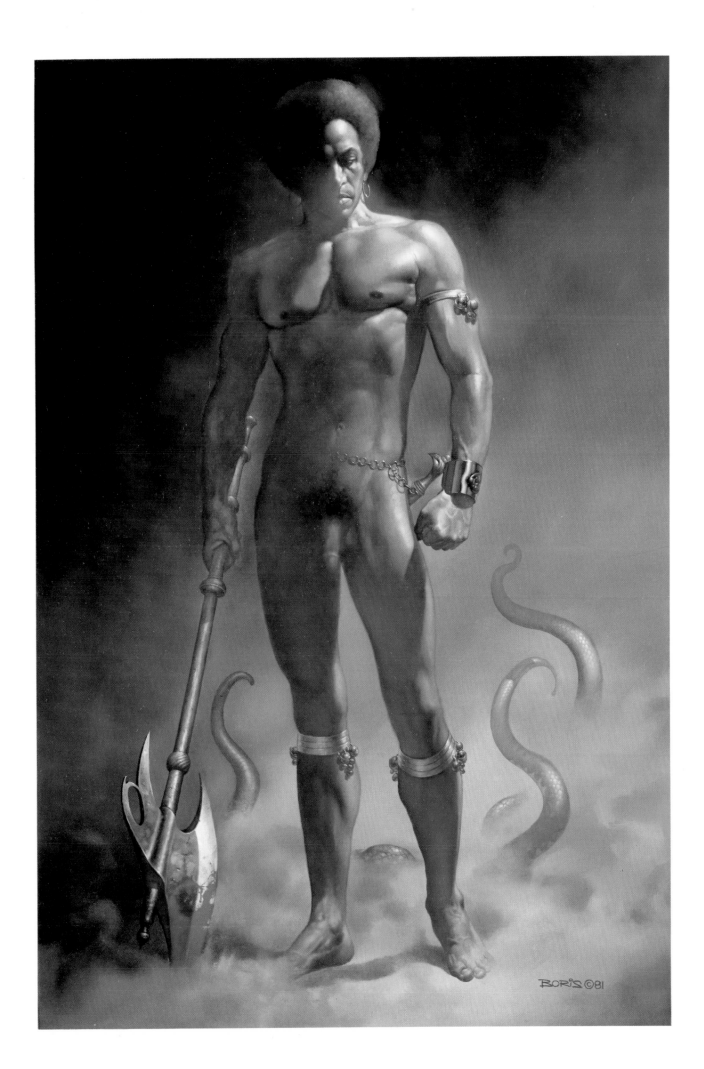

Sunken waves play against our faces
and unfurl opalescent fins
where splintered sunlight glitters
and moss cloaked treasures sleep.

Currents turn us into wanderers
slipping ever farther from the shore
seeking gardens where sea flowers blossom
in profusion
from abandoned pearly shells.

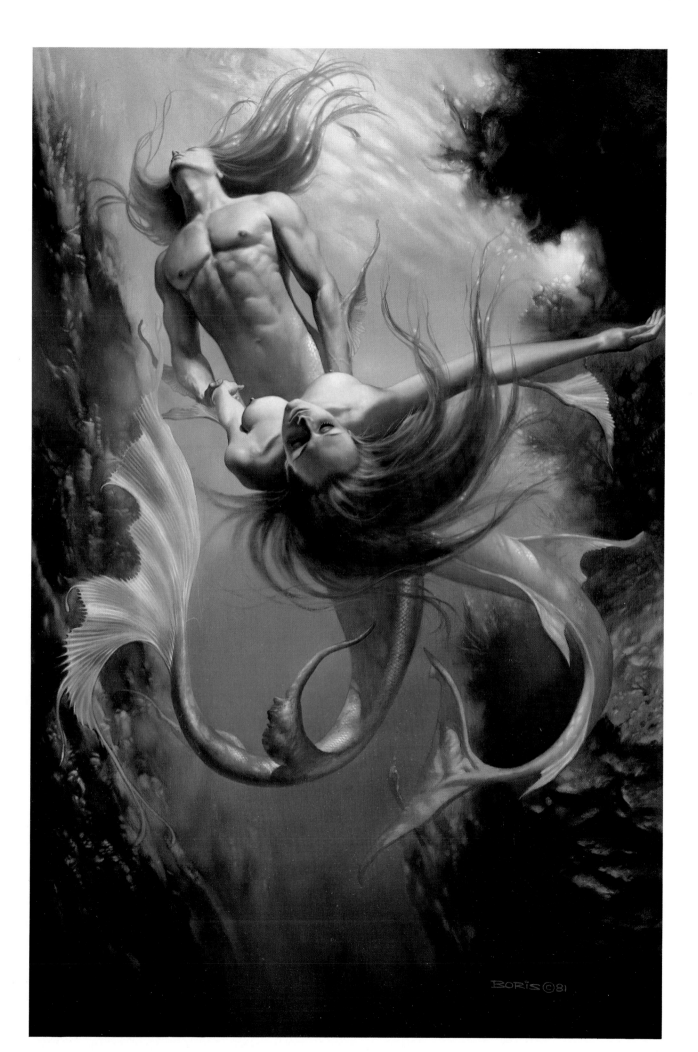

Dragon stained skin
camouflages
live dragons that sing
of heros
wounding each other
at the edges
only
so their hearts
will remain
intact.

Conceived
in the wide womb of legend,
born into a narrowed world,
dragons,
no longer invulnerable,
ride the arms of mortals
and sing.

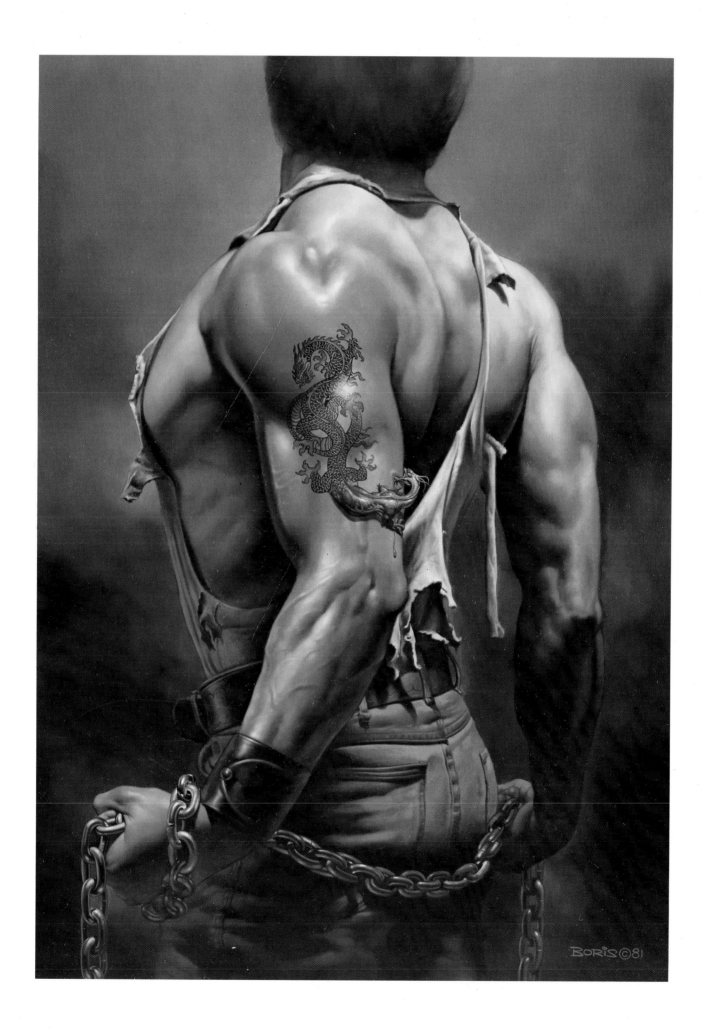

BORIS VALLEJO, born in Lima, Peru, is one of the world's foremost fantasy illustrators. He has gained international attention for his stunning science fiction and fantasy illustrations. His work appears on the covers and inside books by such writers as Edgar Rice Burroughs, Alice Chetwynd Ley, Frederik Pohl, Larry Niven and Lin Carter, as well as in such well-known series as Conan, Tarzan and Doc Savage. With *Mirage*, he has created his strongest and most original work to date.

DORIS VALLEJO, a native New Yorker, was a successful illustrator before turning to writing. Her publications include a children's book, *The Boy Who Saved the Stars*, and a science fiction novel, *Windsound*.